THE ART
OF MATH AND SCIENCE

THE ART
OF MATH AND SCIENCE

JAYANTI TAMBE

First Edition published globally by
Read Out Loud Publishing LLP in 2016
ISBN: 9780997937602
Photography by Jayanti Tambe and Urszula Jaskółka Beaudoin.
Interior and Cover Design by Urszula Jaskółka Beaudoin
www.thebearandswallow.com

I dedicate this book to my mother,
Suguna Rangaswami, who has always
shown me, by example, how important
it is never to stop thinking and wondering.
Amma, you inspire me

66 *Children must be taught* HOW *to think,*
not what to think. **99**

MARGARET MEAD

CONTENTS

FOREWORD

As a director and as an educator, I have focused on what it means to prepare our children for their future equipped with 21st-century skills. Educating our youngest learners in Science, Technology, Engineering, and Math (STEM) concepts will be an essential skill for lifetime success. Integrating STEM theories should be genuine and intentional, and this book meets both those criteria. Jayanti Tambe's emphasis on research, exploration, curiosity and discovery is in complete alignment with what children need to understand of scientific and mathematical concepts in ways that make sense.

In *The Art of Math and Science*, Jayanti gives science and math concepts their rightful place alongside social science and art in the preschool classroom. She sees art through the lens of STEM and explores how these ideas can offer us a new way of looking at and approaching curriculum as a whole. She artfully shows the reader how expanding ideas can give way to abundant opportunities that allow children to make connections between domains.

Jayanti considers art specifically and approaches it as a discipline. In addition to the rich history of artists, mediums, styles, and perspectives of art, she shows the reader very real

opportunities to learn about science and math. In this rich text, Jayanti connects the reader to the artist within every child. The art, the various mediums, the scientific concepts, the math behind the method, the cultural context are all woven together in perfect harmony.

Jayanti takes the teacher on a culture field trip around the world. The activities she has chosen are age and developmentally appropriate, using materials that are easily attainable. The content of each chapter is profoundly sophisticated and yet simple to execute, making the job of the teacher easier. The year-long lesson plans could be integrated into any curriculum framework. I'm confident that our teachers will enjoy using *The Art of Math and Science* as much as I have, and I'm looking forward to adding this valuable resource to our library!

Susan Wood | Director
Phone: (626) 395-6860 | Fax: (626) 793-7308
Website: childrenscenteratcaltech.org

INTRODUCTION

66 *The knowledge of all things*
is possible. 99

LEONARDO DA VINCI

[1]As author, Loretta Jackson-Hayes says, "Our culture has drawn an artificial line between art and science, one that did not exist for innovators like Leonardo da Vinci and Steve Jobs. Leonardo's curiosity and passion for painting, writing, engineering and biology helped him triumph in both art and science."

This artificial line didn't exist in the preschool environment either. Today's world needs to go back to the old order of Dewey. "Education is not preparation for life. Education is life itself," said John Dewey, American educational reformer and psychologist. We don't need to teach our young children to be engineers, scientists, and astronauts. We need to prepare them to be citizens of tomorrow's world, and that requires us to look way beyond STEM studies in early childhood. But you don't need to look far, for art and language support the two pillars of STEM: Science and Math. By actively engaging children in exploring scientific and mathematical concepts through technology, engineering, and the arts, teachers make education more real for the children.

Most people are not comfortable showing the work of famous artists to children, perhaps because they may be intimidated. This book is a guide for early educators and will help integrate the subject of art, math and science. The book is planned to help children look at 'masterpiece art' through the lens of math and science. Children do not learn in pockets. They are sensory learners and are more involved in the process than the product.

Children should learn to appreciate art. We do not require them to copy art; instead, we want them to be able to interpret 'masterpiece art' in their way. The book takes you on a journey of exploring artists/art from around the world. Each chapter has a world map so that the child can understand from his/her perspective where the artist lived/lives and a passage about the history of the artists (to help children understand the role of history and culture). Each artist's work is viewed through the prism of math, so that art is no longer merely art, but it is an integration of the subject of art, math, science, history, geography, and language. This idea of assimilation is also in line with the expectations that most educational systems around the world want for the youngest of our children.

[2]Preschool Learning Foundations for the State of California clearly states: When taking an in-depth look at one domain, one needs to keep in mind that for young children, learning is usually an integrated experience. For example, a young child may be concentrating on mathematical reasoning, but at the same time, there may be linguistic learning that results from the experience.

This book follows the learning expectations laid out by Preschool Learning Foundations for the State of California:

a. The mathematics fundamentals outlined in this book cover the following five areas:
1. **Number Sense** — includes an understanding of counting, number relationships, and operations.

2. **Algebra and Functions (Classification and Patterning)** — focuses on sorting and classifying objects and recognizing and understanding simple, repeating patterns.

3. **Measurement** — includes comparison and ordering.

4. **Geometry** — highlights on properties (shape, size, position) of objects and its relation to space.

5. **Mathematical Reasoning** — addresses how young children use mathematical thinking to solve everyday problems.

b. The foundations for visual and performing arts address a broad range of competencies that preschool children will need support to learn. This book focuses on visual art — it includes noticing, responding to, and engaging in visual art; developingskills and creating, inventing and expressing through visual art.

c. In this book, the history or social science basics focus on the following two areas:

1. Sense of time (History)
2. Sense of place (Geography)

d. The book also addresses the domain of science, which consists of the following four subject areas that are dealt in the book.

1. Scientific Inquiry
2. Physical Sciences
3. Life Sciences
4. Earth Sciences

[3]The NCERT that lays the foundation for preschool principles of education in India also stresses on the integration of subject areas in the preschool years. Preschool education should concentrate on the "concept and importance of school

readiness particularly from the epistemological perspective of education of mathematics, science, language and early literacy and its contribution to ensuring a smooth transition for children from preschool to primary by being able to provide appropriate learning opportunities and experiences."

Through the manipulation of different lenses, children integrate learning in all of the subjects in a developmentally appropriate way.

In this book, as we go through the works of artists, we take the children on a journey of exploration and integration of subjects. In fact, science and math concepts and processes are the content that children engage in while doing the art activities outlined in this book.

1. **History and culture:** When this style of art began
2. **Geography:** Looking at the world map, always relative to where a child lives
3. **Language:** Expanding and extending children's language
4. **Art:** Understanding and appreciating art
5. **Math and Science:** Building a foundation of the scientific process

Early child educators realize that the walls that exist between art, science, and math are non-existent. As they say, science is a process; it is not what you teach, but how you teach. This principle applies to art too. John Muir, author and philosopher, said: "When we try to pick out anything by itself, we find it is tied to everything else in the universe." So it is. By trying to look at art carefully and critically, one realizes that it is closely linked to science and math. It is important to remember that children have the natural desire to find answers to questions, and to come up with creative solutions. They apply this sense of curiosity to all that they come in contact with.

Looking at art through a math or science lens takes you through the step-by-step process of the scientific method:

1. Children explore, identify, classify, compare, hypothesize, predict, observe, ask questions, generalize, and build their concepts through hands-on experiences.
2. As in the scientific method, teachers extend children's learning by asking open-ended questions that both expand and extend a child's learning.
3. Teachers scaffold the scientific method by observing children and then equipping the environment with material that deepens their curiosity and their exploration of the subject.

When viewed through the constructivist approach to learning, we realize that children go through the same seven steps when looking at art as they do when engaged in a scientific experiment. Arleen Pratt Prairie, in her book, *Inquiry into Math, Science and Technology* outlines the steps as:

1. **Question:** to build understanding
2. **Observe:** to gain understanding
3. **Analyze:** to find patterns
4. **Synthesize:** to make predictions and create hypotheses
5. **Reflect:** to consider perspectives
6. **Research:** to search for answers
7. **Communicate:** to share the results of their thinking.

So, as children investigate and explore the wonders of 'masterpiece art', they become scientists. Provided with the right environment rich with provocations, guided by thoughtful, reflective teachers, children naturally thrive, and learn. As 19th century educator, Charlotte Mason rightly said, "Children are born with all the curiosity they will ever need. It will last a lifetime if they are fed a daily diet of ideas."

CHAPTER I

WASSILY KANDINSKY

• RUSSIA

ART TO OBSERVE

Color Study
Squares with Concentric Circles[4]

• The science and math behind the activity:
Learning about shapes, circles, colorss and using tools
(compass and scissors)
• Child development: Fine motor development in
young children

WASSILY KANDINSKY was a Russian artist best known for his abstract work. He summarized his art thus: [5]"I applied streaks and blobs of color onto the canvas with a palette knife, and I made them sing with all the intensity I could..." Many of Kandinsky's artworks consist of geometric shapes and lines. There is also an abundant use of both color and texture. Upon a closer analysis of his paintings, another mathematical concept comes to light—his use of proportion. These elements, when seen together paint a colorful picture and are readily appreciated by young children.

Kids take to abstract art like ducks take to the water. As authors, [6]Annie Conner and Jamie Hawks-Malczynski state in their article, "Unlike representational art, which is intended to look like something recognizable (like a picture of a flower), abstract art isn't meant to resemble anything." Abstract art, simply put, is not at all intimidating to children.

During the preschool years, children progress through stages of art — from small scribbles to creating what we can see and understand as recognizable objects. As they move developmentally through this process, exposing them to the work of abstract artists such as Kandinsky gives them the confidence to say, "Hey, I can do this too!"

Materials needed

a. Large sheet of poster board or clear contact paper
b. Circle stencils or cutouts
c. Geometry instrument: compass
d. Colored construction paper
e. Scissors
f. Glue sticks

Set up

Setting up an art activity for children centered around Kandinsky's work is relatively uncomplicated.

a. Attach the contact paper (sticky side out) or the poster board on the wall. Or place it on a table.

b. Give older preschoolers compass to draw circles and scissors to cut them out. Children who are between the ages of four and five are ready to experiment with tools, and so this stage lends itself perfectly to the exploration of geometric instruments such as rulers and compasses. Provide these children a flat surface to work.

c. Younger preschoolers are not yet adept at using a pair of scissors. It is then prudent to use pre-cut shapes for the activity. For younger children and toddlers, it is an excellent idea to use clear contact paper or poster board with glue sticks.

d. Three-year-olds love using stencils, which help them, build their fine motor skills. You can use stencils instead of giving them pre-cut circles.

e. Once the material is ready, talk to the children about Kandinsky. The book about the artist as a little boy, *The Noisy Paintbrush* by Barb Rosenstock, is an excellent introduction to Kandinsky's work.

f. Ask children open-ended questions about what they see in Kandinsky's art.

g. Ask the children to create a picture they think Kandinsky would have thought of creating if he visited their classroom. Do not provide an example; allow children to interpret his art on their own.

h. Now, let the children glue the circular shapes on the poster board. If using contact paper, use the sticky side up. Allow children to place the shapes on the sticky surface.

Fun extension of the activity

Introducing young children to math words is important. Just as teachers create word walls for language instruction, try to create a math/science word wall for the artist's work that the kids are observing. Write down all the words that

children use for shapes, colors, and perhaps the textures that they "see."

The science and math behind the activity: Learning about shapes, circles, colors, and using tools (compass and scissors)

Children will have the opportunity to explore shapes — circles and lines. It is in the preschool years that children learn to identify and name basic shapes such as circle, triangle, square, rectangle, and oval. Children will get to use tools such as stencils, scissors, and compass. They will learn about and explore colors and the concept of size. For children who enjoy sensory experiences, the sticky surface of the contact paper will afford them an enjoyable experience.

Child development: Fine motor development in the early years

Children need manipulatives to work their hands. Manipulatives are tools that help enhance and strengthen a child's fine motor skills. They exist in most classrooms in the form of blocks, Legos, small cars, etc. By handling objects like blocks, beads or cars, children develop better hand-eye coordination; their handedness (left or right) gets determined, and they are more prepared to hold a pencil and write in their elementary years. Having access to easels in the classroom is important. While we give children a lot of drawing and writing exercises on paper on a table or flat surface, we neglect the value that easels provide. When a certain amount of body stability has developed, the hands and fingers begin to work on movements of dexterity and isolation as well as different kinds of grasps.

There is a continuum regarding hand development in young children, and it is this knowledge that helps teachers equip their environment in such a manner so as to enhance the process in young children. When children begin to hold

things, they start with the fisted grasp. Between the ages of one and two, young children tend to hold toys, pencils, crayons and other utensils with their entire fist. Then they move to the palmar grasp, around ages two and three. It looks the opposite of the fisted grip. The child's thumb will point down, and the little finger will be up and off to the side; the elbow will also stick out to the side. From the palmar grasp, young children aged four and five move on to the five-fingered grasp, an immature grip. All five fingers are engaged in this grip, as the child uses four fingers to push a utensil against his thumb. Most children reach a mature three-finger grip by age five or six. In this hand-grip, a utensil is held between the thumb, index and middle fingers. When children do not have anything to work their hands around, it is not just writing that suffers, everything is affected – physical/motor, cognitive and even social-emotional development.

[7]Research quoted by Christopher Bergland on his blog suggests that creating a robust connectivity between both hemispheres of the cerebrum and both regions of the cerebellum is key. This new research on the role of hand-eye coordination in the early development of toddlers is another clue for practical ways that we can give toddlers and children the best odds for learning; create social connectivity and also lay the neural groundwork for maximizing their potential. Bergland says, "These initial neural connections will play a crucial role in optimizing a child's human potential for a lifespan." Play dough, small cars, balls, etc. are necessary materials to help strengthen these neural pathways. The significant push for the classrooms should be to equip the environment with materials that will assist to establish stronger hand-eye coordination. Daily activities should include cutting paper (if the paper is available) or cutting and using play dough (which can be homemade), tearing and crushing paper, using tongs or tweezers – mainly actions that require the fingers to work the muscles of the hands.

Pre-cut circles for Kandinsky inspired artwork and sticky contact paper for younger children and toddlers

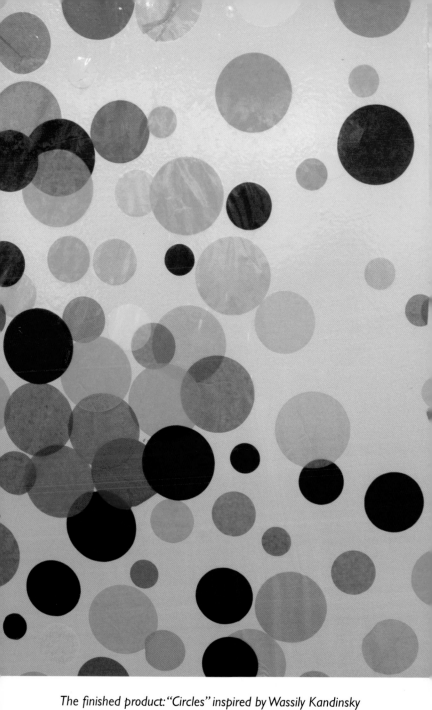

The finished product: "Circles" inspired by Wassily Kandinsky

CHILD

..

66 *This reminds me of loops and hula hoops, and balls and balloons. I like Kandinsky. He makes me feel so happy.* **99**

..

CHAPTER 2

VINCENT VAN GOGH

HOLLAND

ART TO OBSERVE

Starry Night [8]

- The science and math behind the activity: learning about magnets, paint blending, and color mixing
- Child development: The stages of drawing

VINCENT VAN GOGH was born in Holland but spent his later years in Belgium and Paris. His artwork is full of intense hues and masterful brushstrokes. Van Gogh had the ability and the perception to see colors differently, and it is this reason why his art resonates so well with young children. [9]"There is no blue without yellow and without orange." Van Gogh's *Starry Night* is an excellent piece of artwork to introduce to young children. They enjoy the colors and the swirly patterns of the clouds. This painting depicting the night sky lends itself readily to be appreciated, interpreted and re-created by young children, in their way. I use a non-threatening way of introducing this artwork to children.

Materials needed

a. Sheet of Plexiglas or plastic
b. Magnets
c. Steel balls
d. Paint: Blue, Black, White and Yellow (and any other color a child says he/she "sees" in the night sky)
e. Silver glitter
f. Bowls for the paint
g. Plastic spoons
h. Large sheets of black construction paper

Set up

This activity takes time because only one child at a time can paint. I often read books to the children about the night sky and discuss what they might see in the sky.

Questions that you can ask include:
1. What colors do you see in the night sky?
2. What shapes do you see?
3. Do you see many stars in the sky?
4. Can we make some of the colors of the sky?
5. Do you see any patterns in the sky?

Once you have talked to the children about the sky (either by showing them a picture of the sky or by reading a book), then you can show them the picture of Van Gogh's *Starry Night*. Try and link their ideas with the painting. Then...

a. Pour paint in cups. Let the child choose the colors of paint that he/she wants.

b. Add one steel ball to each bowl of paint.

c. Add silver glitter to the darker colors.

d. Place spoons in bowl.

e. Attach a sheet of clear plastic or Plexiglas between two tables.

f. Let the child spoon the paint along with the steel balls to the top of the Plexiglas.

g. Then tell the child to lie down *under* the sheet of Plexiglas.

h. Give the child a bar magnet. Show him/her how to move the steel balls (and the paint) on the Plexiglas using the magnet.

i. Converse with the child about the colors and patterns that he/she is creating.

j. Once the child has completed working with the magnets and paint, as an extension, help him/her place a piece of black construction paper on the painted side of the Plexiglas. Take a monoprint of the art by lightly placing hands flat on the paper. Remove. Dry the monoprint. (A monoprint is an impression of the image: in this case, it's the impression created on the Plexiglas.)

k. Make sure to remove the steel balls before taking the monoprint.

The science and math behind the activity: Learning about magnets, paint blending, and color mixing

In exercises using magnets, children learn about the theories of physics (attraction), chemistry (viscosity of paint) and mathematics (patterns). Mastering of these concepts will support children's understanding of academic subjects in later schooling and life. Thus art is indeed "serious play" for young children. Science is everywhere around us. What can children do to increase their understanding of science? Everything! Children inquire, observe, compare, imagine, invent, design experiments, and theorize when they explore natural science materials such as water, sand, and mud.

It is important to know that when children play, they integrate their senses, and they combine their domains of learning to make sense of the world that they live. [10]Alison Gopnik of UC Berkeley describes this phenomenon as children's scientific thinking. She states that when engaged in what looks like child's play, preschoolers are behaving like scientists. According to a new report in the journal *Science*, they are forming hypotheses, running experiments, calculating probabilities and deciphering casual relationships about the world.

Through this art activity, children can engage in three skills for lifelong learning: creativity, collaboration (with peers) and communication (as they describe their art to their peers and the adult.)

Why magnets and steel balls?

When we look at circles and swirly patterns in art, it is important for us to consider the range of hand development in young children. Circles and swirls are difficult for the small muscles of preschool hands to draw. By giving children steel balls that they can manipulate with magnets, you help them create the round patterns that they see in a fun and developmentally appropriate way. Steel balls are spherical

and roll smoothly on the surface, and as the magnet drags or attracts the steel balls across the paint, these create the round and swirly patterns.

Child development: Stages of drawing

Art for kids must be about the process and not the product. It is about the development of muscles, ideas, and imagination. It is about the growth of the child. What it is not is the development of a final product. Rhoda Kellogg was a psychologist and a nursery school educator who spent many years collecting the scribbles of young children. She categorized them into distinct stages of art development. She found children's art to be a sequence of basic shapes: they began with early scribbles from random dot placements and grew to more deliberate scribble patterns. Kellogg discovered that in their artwork and scrawls, children develop placement patterns, new diagram shapes, *mandalas*, sun, and radials, before drawing humans.

[11]Viktor Lowenfeld, in the 1940s also looked closely at children's art and found them to go through five distinct stages:

1. **Scribble:** Lowenfeld stated that children between the ages of two and four are at this juncture of art. They go through uncontrolled stages to a more controlled one. At the more sophisticated and mature part of this phase, many children can name their art ("Look, I made a car"). While it may not seem like a car to an adult, Lowenfeld stressed that children reach a period of maturation where they can label their art.
2. **Pre-schematic:** In this juncture, human or animal figures begin to appear but are randomly or haphazardly placed on the paper.
3. **Schematic:** There is deliberate planning during this phase. Shapes are well-defined and recognizable.

4. **Drawing Realism:** According to Lowenfeld, it is at this stage, that children are affected by peer pressure. As a result, they are self-critical, and thus their drawings appear less spontaneous, and more often, quite stilted.

5. **Pseudo-realistic stage:** This is the period where children are more bothered by the end product. Children are affected by what they see (visual stimuli) and what they feel (emotional stimuli), and their drawings are representative of both.

Van Gogh's "Starry Night" created with magnets and paint

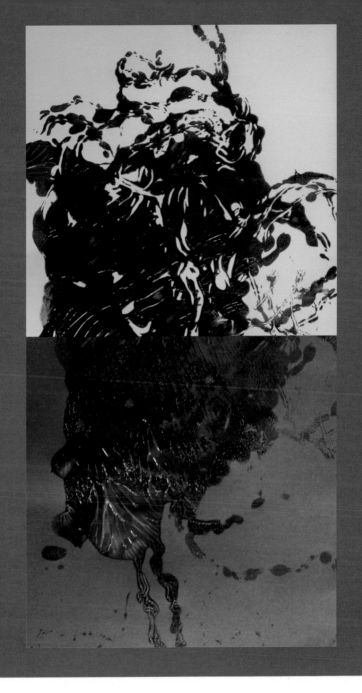

A monoprint of "Starry Night" inspired creation

CHILD

..

66 *Painting this (Van Gogh's) is like painting Jackson Pollock...no, that guy who painted on the ceiling. What's his name? Michelangelo?* **99**

..

CHAPTER 3

MICHELANGELO

ITALY

ART TO OBSERVE

Ceiling of the Sistine Chapel[12]

- The science and math behind the art: Learning about gravity, viscosity, and distance
- Child development: Piaget and Egocentrism — why perspective is critical

[13]MICHELANGELO was born in Tuscany, Italy. When he was a young boy, he loved watching people paint. He adored it so much that he went to learn painting with a master artist. He enjoyed painting the human body and would spend hours looking at and understanding human anatomy. He was not only an artist but also a sculptor. He sculpted a 14-foot statue of David for the Cathedral in Rome. Michelangelo was so adept at painting or sculpting human forms that the ratio that he used for it is referred to as the Golden Proportion.

Materials needed

a. Large sheets of paper
b. Tape
c. Tempera Paint
d. Cups
e. Large paintbrushes
f. Small wooden artist mannequins to show human body proportions
g. Towels for clean up

Set up

a. Tape sheets of paper *under* the table. Teachers usually place paper either on the table for children to draw or on a wall or an easel. It is rare for them to have a paper under a table. As educators, we need to give children opportunities to understand different perspectives and ways to look at ideas, since this helps children grow and develop to be more capable adults.
b. Mix paint in containers.
c. Place paint under the table with long paintbrushes.
d. Invite the children to look under the table at the taped canvas or paper, and talk to them about how they can also paint in the way that

Michelangelo did. Just as he painted on the ceiling of the Sistine Chapel, ask the kids if they too would like to try and paint on the *"ceiling"* of the table.

Setting up this activity for children is always fun because it allows them to look at things differently. It also brings up a host of questions, the most important of which is: "Why are we painting under a table?" I try and set the stage for this one because young children don't always understand that showing them to paint on paper under a table doesn't mean that it's okay to paint on furniture! Conversations about what is going to happen in a classroom are important — they help set the stage for future expectations.

Ask children open-ended questions:

a. Michelangelo painted pictures on the ceiling of the Sistine Chapel. How do you think he could have painted up so high on a ceiling?
b. Can you think of ways to reach a ceiling?
c. Would you think a person would have to lie down to paint or stand up to paint a ceiling? Tell me why?
d. What problems would someone like Michelangelo have while painting a ceiling? (Expect the unexpected. One of the children I worked with once commented, "Michelangelo must have got many headaches if he did this for a long time.").
e. How long would it take to paint the ceiling of our classroom? How many people would it take?
f. Would you use special tools or paint?

The Science and Math in the activity: Learning about gravity, viscosity, and distance

The children need to stretch their arms to reach the table. They also need to contort their bodies or move to reach a corner they wish to paint. By looking at the wooden mannequins provided, children will also have a better understanding of the human body and its proportions. If you give them paints in different consistencies, you give them the opportunity to understand the property of liquids. If the paint is runny, it will require children to clean their paintbrushes well before painting on the paper above them. If you give them heavy, thick paint, it might clump and fall on them in blobs. Children also need to have an understanding of space, since they need to share the space under the table and also the paper above them. I vary the size of the paintbrushes to allow children to experiment with distance; include both long and short brushes.

Fun extension of the activity

Use glue instead of paint, and provide the children with small objects to glue onto the paper. Make sure that some of the items are heavy (small pieces of wood, twigs, etc.), and some are light (cotton balls, feathers, etc.) It allows children to explore the concept of gravity further.

Child development: Piaget and Egocentrism — why perspective is critical

Egocentrism refers to the child's inability to see a situation from another person's point of view. According to Jean Piaget, pioneering clinical psychologist, "The egocentric child assumes that other people see, hear, and feel the same as the child does." When working with children in the pre-operational stage, teachers must be 'intentional' in their planning for play. Author Marilyn Rice, in her article, What

is the teacher's role in supporting play (and learning) in early childhood classrooms? throws light on this topic. She states that planning should not be accidental ("It just happened…"). On the contrary, she stresses that "…it should be something that the teacher planned and intended." According to Rice, "Play (and other activities such as exploration, sensory play, and art experiences) serves several functions in contributing to children's social and emotional development when they assume new roles that require new social skills and take the perspectives of their peers."

[15]Patrick Hill and Daniel Lapsley in their article on egocentrism emphasize that "children learn how to take the perspectives of others better through interacting with their peers than with adults." That's why it is important for children to engage in activities where there may be different ways of looking at things, or where space and ideas may be shared, since these result in appreciation and understanding of differing perspectives.

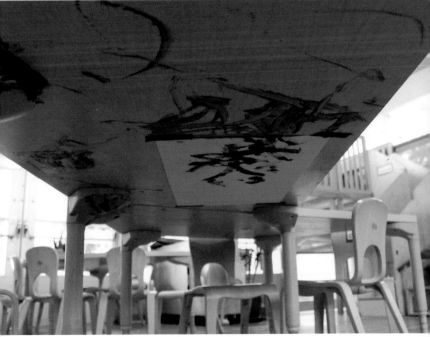

Michelangelo's Sistine Chapel requires paper to be taped under a table so children can paint the "ceiling"

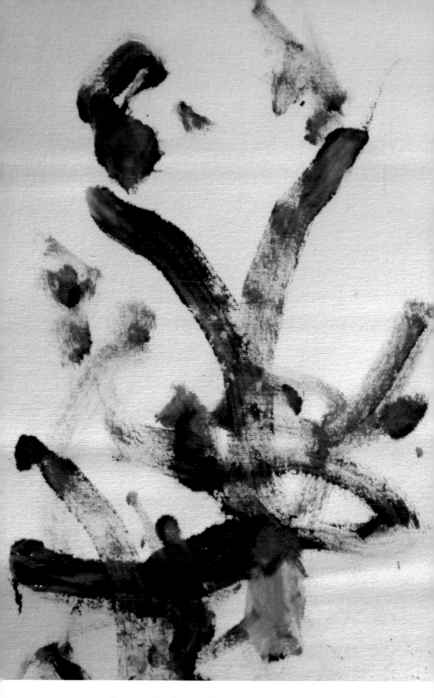

Painting the "ceiling" of the Sistine Chapel

CHAPTER

TEACHER

..

" *What kinds of problems do you think Michelangelo would have had while painting the Sistine Chapel?* **"**

CHILD

..

" *I think he must have had many headaches.* **"**

..

CHAPTER 4

GEORGIA O'KEEFFE

ART TO OBSERVE

Sunflower, New Mexico [16]

- The science and math behind the activity: Learning about flowers, structure, colors and scent
- Child development: Why children need to observe

GEORGIA O'KEEFFE was an American artist renowned for her paintings of landscapes and flowers. She made her home in the state of New Mexico where she spent many hours painting the desert landscape in vibrant hues of red and yellow. According to [17]Lisa Messinger, from the Metropolitan Museum of Art, "It was the region's majestic landscape, with its unusual geological formations, vivid colors, clarity of light and exotic vegetation that held her attention for more than four decades." O'Keeffe is also famous for her paintings of the often dramatic close-ups of flowers.

Materials needed

a. Large Sheets of drawing paper
b. Oil Pastels
c. Bowls
d. Vase with fresh Flowers
e. Small tweezers, scissors

Set up

a. Place the paper on the table
b. Place oil pastels in the bowl
c. Place vases of fresh flowers on the table
d. It is a relatively easy art activity to set up since it requires nothing extra or special other than vases of fresh flowers. If possible, procure dramatic looking flowers (like orchids, or real powder puff flowers — *Calliandra haematocephala*).
e. Children also need to touch, maybe even smell the flowers that they have. Teachers should ensure that none of the flowers that are used for art projects or placed nearby to children are poisonous. Some kids may even try and taste the flowers!

f. I usually have a conversation with the children about the different parts of a flower. I allow children to use small instruments like magnifying glasses and tweezers so they can remove the tiniest of the parts of the flower to examine carefully.

g. Then, I invite the children to draw the flower in the way they think that Georgia O'Keeffe might have done.

Ask open-ended questions:

a. What shapes do you see in this flower?
b. How would you describe its texture?
c. Do pastels have this texture?
d. What can we add to our materials to create this texture?
e. How can we draw tiny things to make them look huge?
f. What do you like about Georgia O'Keeffe's artwork?

The science and math behind the activity: Learning about flowers, colors, scent, structure, and size

This art activity focuses on the power of observation. Children use tools like magnifying glasses, and tweezers to carefully examine the parts of a flower. I usually create a word wall about the parts of a flower. I also introduce the term, "magnified" to the children when looking at close-up images of flowers that O'Keeffe painted. Children use math words like "bigger," "huge," "magnified," to describe what they see when using a magnifying glass. This activity invites children to use their sense of touch, sight, smell, and perhaps, even taste.

Child development: Why children need to observe

According to an article in the [18]Smithsonian, "By carefully looking at the objects (children are) seeing... children's minds become engaged, and the objects become learning tools." The author adds that this observation "...acts as a springboard for new thoughts and ideas, stimulating the use of critical thinking skills such as:

- **Comparing and contrasting** — recognizing similarities and differences in objects.
- **Identifying and classifying** — identifying and grouping things that belong together.
- **Describing** — giving verbal or written descriptions of the objects viewed.
- **Predicting** — guessing what might happen.
- **Summarizing** — presenting information that has been gathered in a condensed form."

In fact, with the Common Core (a set of academic standards in mathematics and, English language arts, and literacy) in states like California, teachers have been advocating for young children to have more activities where they need to observe works of art keenly.

[19]Elizabeth Levett, a kindergarten teacher at George Peabody Elementary in San Francisco, is quoted in Susan Frey's article, *Art appreciation helps young children learn to think and express ideas*: "Everyone is worried about kids having access to technology... They need to learn how to look slowly, actually observe. Everything in technology is a click, click, and click. This method (observation of art) hones the craft of looking deeply and listening to each other."

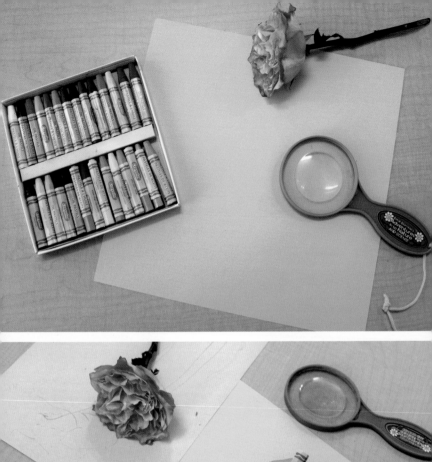

Georgia O'Keeffe inspired flowers- looking closely at structure and form

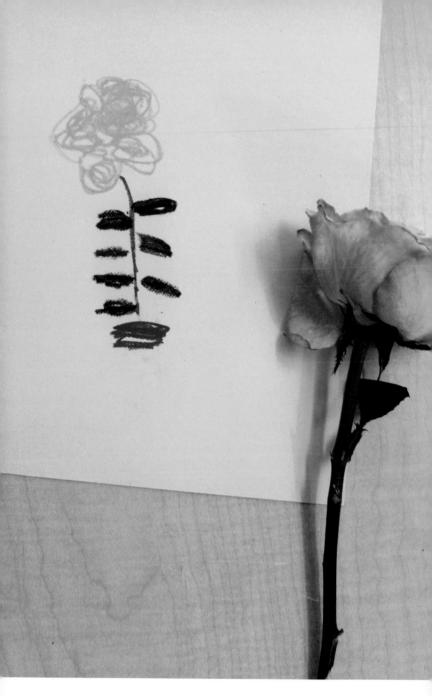

A Georgia O'Keeffe inspired Rose

CHILD

66 *I like flowers.*
They smell nice. **99**

CHAPTER 5

INDUS VALLEY CIVILIZATION (SCULPTURE)

ART TO OBSERVE

The Dancing Girl of Mohenjo-Daro[20]

- The science and math behind the activity: Learning about the human body and proportion
- Child development: Why children need to visit museums

THE INDUS VALLEY CIVILIZATION flourished in the 2nd and 3rd millennium BCE. The people of the Indus Valley mostly used clay to make small toys and seals. Their artifacts showcase elephants, antelopes, rhinoceros, and tigers. Two of their sculptures survive to this day, the most famous of which is the *Dancing Girl* — a four-inch bronze figure, located at the National Museum, New Delhi, India. In addition to a picture of the Indus Valley *Dancing Girl*, I try and provide children with small clay figures or brass statues and figurines to look.

Materials needed

 a. Rolls of aluminum foil
 b. Small wooden bases (2-inch squares)
 c. Glue Gun
 d. Glue sticks
 e. Small art wooden mannequins

Set up

 a. Cut aluminum foil into 12-inch squares.
 b. Heat glue gun. Adult supervision is required.
 c. Let children crush the aluminum foil to create their sculptures. This kind of tearing and crushing of aluminum foil helps to build the muscles of their hands.
 d. Allow 'sculptors' to attach their sculptures onto the wooden base. I like this part the best because children feel like "real" sculptors when their figurines are attached to a base as it looks so much like the real thing!

[21]Rachel Doorley provides five valuable tips on how to talk to children about art (I use these tips for talking to children about sculpture).

1. **Find real art:** I sometimes go to small craft bazaars or flea markets to purchase *real* sculptures. Real art provides children with an entirely different perspective on three-dimensional art.
2. **Be open-minded:** More often than not, children will interpret what they *"see."* It may not look like what you expect it to look. (They may make a statue of an elephant that might lack a trunk. Always remember, this is how children "see" their art).
3. **Encourage careful looking:** Observation is critical. Provide magnifying glasses and foster a closer view, if possible.
4. **Ask open-ended questions:** My favorite question is, "What would you call this piece that you have created if you had to give it a name?"
5. **Look for an opportunity for related art-making:** It can help strengthen a child's understanding and critical thinking skills as they interpret what they see in two or three-dimensions.

Fun extensions to the activity

I bring books on bones and joints for the children to understand how their bodies work. We have created paper figures to see how the legs and arms work when attached to the shoulders, knees or elbows using paper fasteners (brads). This kind of understanding helps children make more anatomically correct sculptures. It also helps hone their observation as they understand the complex machinery of a human body.

The science and math behind the activity: Learning about the human body and proportion

A sculpture is three-dimensional. From a mathematical point of view, this means that it occupies space in three dimensions — height, width, and depth. This art activity introduces preschoolers to figurative sculptures where they can learn about the human body and proportion. The aluminum foil allows children the ability to create 'body parts' that they can later twist together to form limbs with joints. This activity gives children a better understanding of how their body works.

Child development: Why children need to visit museums

It's not often that you see a bunch of preschoolers discussing the art style of Michelangelo or that of Pollock. It makes taking young children to museums very necessary (despite how exhausting the trip might be). Not only is it exhausting, but it is also unnerving since children tend to learn through the sense of touch. I always talk to the children about what they are going to see. I familiarize them with the art that they might observe, and also with the names of some of the artists and sculptors. I also walk them through the steps of visiting places like museums. My mantra is: always, "look with your eyes, not with your hands!"

What can children learn from objects and paintings in museums? In their paper, [22]*Looking at Art With Toddlers*, Katherina Danko-McGhee and Sharon Shaffer state, "Young children learn to create new meanings through interaction with art. Thoughtfully planned visits to traditional art museums could be valuable experiences for preschoolers, contributing to the growth of aesthetic awareness."

Children are naturally inquisitive and ask numerous questions. Adults can have great conversations with their children not just by listening, but by asking the right

questions. [23]These three questions are right questions to ask of children when they are viewing a piece of art in a museum:

a. What is going on in this picture or sculpture?
b. What do you see that makes you say that?
c. What more can we find?

I sometimes ask them what they might do differently. I also ask the children if they know the medium used: paint, crayons, pastels or charcoal? I carry clipboards with me so children can sit down and draw what they think is their favorite picture or sculpture. I use several tools to help them recall what they have seen during a museum visit as it helps the children become better observers.

As [24]Rebecca Gross, in her article, *The Importance of Taking Children to Museums* states, "They (visits to the museum) can provide memorable, immersive learning experiences, provoke imagination, introduce unknown worlds and subject matter, and offer unique environments for quality time with family."

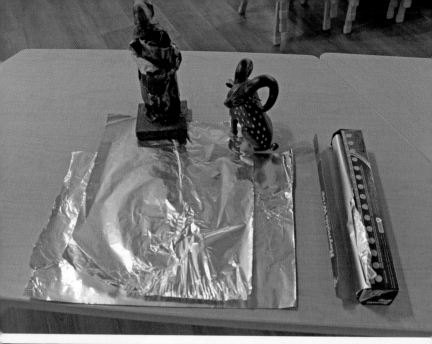

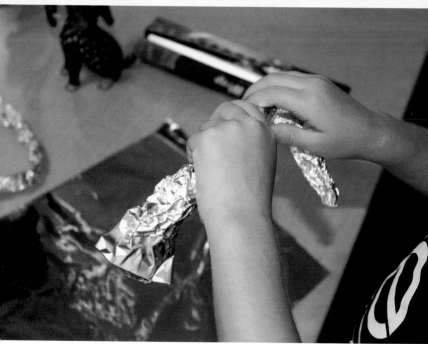

Working with aluminum foil to create sculptures

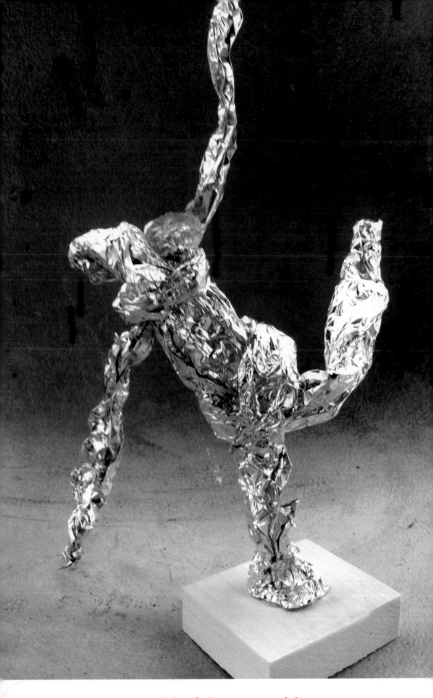

An Indus Valley Civilization inspired dancer

CHILD

......................................

66 *Statues are from a long, long time ago.*
Statues are made of stone and wood.
I would make a statue of a horse because
it would stay for so long **99**

......................................

CHAPTER 6

JACKSON POLLOCK

ART TO OBSERVE

Convergence[25]

- The science and math behind the activity: Learning about height, distance, viscosity, and gravity
- Child development: Importance if messy art in a preschool environment

JACKSON POLLOCK was an American painter, well-known for his abstract art and splatter paintings. While describing his rather radical style, Pollock stated, "The painting has a life of its own. I try to let it come through." He would either lay his canvases flat on the floor or have them propped up against a wall. [26]Pollock "used a style where he would allow the paint to drip from the paint can. This technique was referred to as 'drip and splash'. Instead of using a traditional paint brush, he would add depth to his images using knives, trowels, or sticks." This style of painting resonates with young children because it is non-threatening as they can see themselves as being able to paint like Pollock.

I show Pollock's artworks and ask the children...
a. Describe to me what you see in the picture?
b. How do you think you can make long lines or short lines with a paintbrush?
c. How do you think Pollock made the paint drip?
d. What do you like about his painting?

Materials needed

a. Large white bedsheet, paper or canvas
b. Different shades of tempera or acrylic paint
c. Bowls or containers for paint
d. Paintbrushes
e. Towels for clean up
f. Smocks
g. Shower caps

Set up

a. This activity is fun and allows children to paint with abandon! For this exercise, I usually clear the area as there is a lot of flinging of paint. If you are using acrylic paints, it's is prudent to have the children wear smocks and shower caps. Yes, the paint does get in their hair too!

b. Lay out the canvas/paper flat on the floor.

c. Make sure that you have something that children can climb onto, and also ensure that they are supported when they are at a height. I usually have a wide table that kids can sit on — this gives them the extra height they might want.

d. Talk to the children about how Pollock painted — how he would sometimes let the paint drip onto the paper or fling it in splatters on the canvas. Ask them if they would like a paintbrush to try.

e. The reason this activity is suitable for children is: They need to have freedom of movement of their whole body. Children need to make sweeping movements with their entire upper bodies – shoulders, arms, forearms, hands, and fingers. To fling the paint down, children need to make wide arcs with their shoulders and upper arms, thus crossing the midline of their bodies. Small A4-sized paper doesn't afford children those big movements. Another reason for giving children larger sheets of paper/ or canvas is that young children need to work on crossing the midline. [27]The body midline is an imaginary line running through the center of the body, from the top of the head to a point between the feet. The body pivots about this central core. Midline crossing describes the child's ability to make efficient use of his right hand in the left body space, and the left hand in the right body area.

The science and math behind the activity: Learning about height, distance, viscosity, and gravity:

Through the process of painting, children explore what happens to the size and pattern of the splatter created when they vary the height/distance from the canvas. They observe the length of the drip and vary their height to increase or decrease the length of drip. When they are at a height, they also discover ways of modifying their arm motion to create longer or shorter 'drip lines.' I also vary the thickness of the paint, so children can observe what happens when they use runny, liquid paint, and what happens when they use goopy paint.

Child development: Importance of messy art in a preschool environment

Children need to have the freedom to explore materials more freely, have more sensory experiences, and to enjoy messy art fun. It is through this language of messy media that children express themselves in a variety of ways. [28]Kate Martin, in *Encounters:* A Reggio Emilia Dialogue Within New Zealand states, "Children go back and forth between verbal dialogue and graphic representations, but may also move to different symbolic languages, such as paint, wire or clay, requiring new interpretations of their ideas." The author adds, "This process recognizes and provides an opportunity for strengths of young children to be utilized, and demonstrates the many potentials and capabilities that children bring to their learning."

Messy art is process-based art, where the end product is not the goal of a teacher. Instead, the teacher focuses on the skills acquired in the process of doing the activity. The National Association of Education for the Young Child (NAEYC) describes process-based art as "art with no step-by-step instructions." There is no sample for children to follow. There is no right or wrong way to explore and create. The art is focused on the experience and exploration

of techniques, tools, and materials. The art is unique and original. The experience is relaxing or calming. The art is entirely the child's own. The art experience is a child's choice, and ideas are not readily available online.[29]

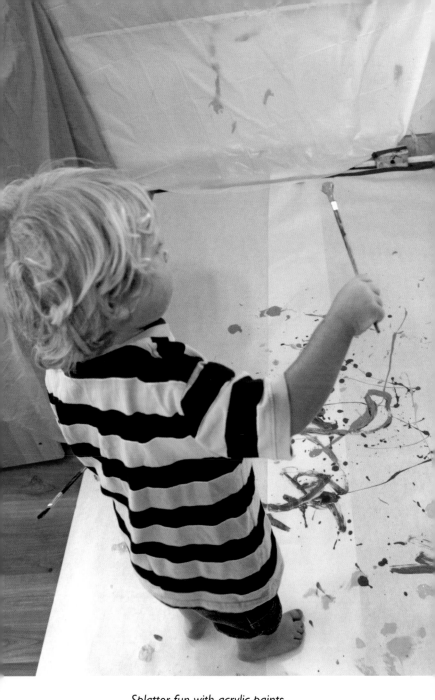

Splatter fun with acrylic paints

A Jackson Pollock inspired masterpiece

CHILD

..

66 *Hold the paintbrush like a bat with both your hands and swing it around. The paint splatters everywhere.* **99**

..

CHAPTER 7

PABLO PICASSO

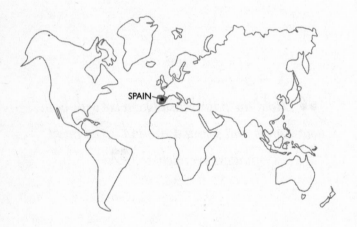

SPAIN

ART TO OBSERVE
Portrait of Dora Maar[30]

- The science and math behind the activity: Learning about observation, mirrors, and proportion
- Child development: Why is it important to have an integrated curriculum in the early years

PABLO PICASSO was born in Spain but spent most of his life in France. He is probably one of the most celebrated artists of the 20th century. Picasso showed his artistic prowess when he was a young child, and he began to take formal art lessons when he was only 16 years old. He was seen as the forerunner in Cubism — a style of painting that he utilized geometric shapes. Picasso experimented with his work and that resulted in several new and popular artistic techniques — the collage was one of them.

His art style is easy for children to appreciate because of the almost lopsided proportions of some of his works. His quote, "All children are artists. The problem is how to remain an artist once he grows up..." sums up why he appeals to the young and the old. [31]Mrs. Eisenbeisz, a fifth-grade teacher said it perfectly when she stated, "Picasso broke the (art) rules and freely created faces with crooked eyes, wild skin colors, and ears in strange places — if he even bothered to show an ear. He was free from rules, and that's what made him feel alive. When people saw this new art, they wanted him to paint their portraits just like that." It is this freedom and abandon that helps children feel at ease while creating their own Picassos.

Materials needed

a. Large sheets of drawing paper. Children do not draw on small sheets of paper. It is developmentally appropriate to give them large sheets of paper so that they have some freedom of movement.

b. Tempera Paint. I usually give the children four different colors (black, white, red and yellow) since almost any skin tone or hair color can be created from these. However, if any child asks for another color choice, it is always provided to them.

c. Brushes

d. Bowls for paint

e. Mirrors

f. Scissors & Glue

Set up

a. Talk to the children about self-portraits. Show them mirrors and ask them about what they see.

b. Use words like "proportion", "reflection," and "symmetry" to describe faces.

c. Ask the children to define the shape of the face that they see in the mirror and invite them to paint the shape on the paper.

d. Then, using the four colors in the palette, help the children find their skin tone. I usually use a cotton swab or a Q-tip to help apply the paint to the child's forearm. Once we have found the child's skin color, I encourage the children to fill the shapes that they have drawn with the paint we have created.

e. Drawing their attention to the mirror again, I encourage them to examine their eyes, nose, hair, etc. and then to paint it on the paper.

f. Once the paint is dry, help the child cut the painting in two.

g. Then assist them to glue the picture onto a piece of card, making sure that the two halves of the portrait are not perfectly aligned — it makes the image slightly lopsided.

Questions to ask the children when they observe the work of Picasso:

[32] Australian art academic Terry Smith wrote about the *"Four Ways of Looking at Art."* Four simple queries: the "what", "how", "when" and "why" are the questions that should be asked of the viewer.

1. What can I see just by looking at this artwork?
2. How was this artwork done?
3. When was it made, and what was happening in art and broader history at that time? (Yes, even this

question is a great one to discuss with young children. Show them maps of the world. Tell them where the artist was born. Explain to them how long it would take to fly in an airplane to reach that country.)

4. Why did the artist create this work and what is its meaning to them and us now? (This one can be simplified for younger children, but the conversation can still be had.)

The science and math behind the activity: Learning about observation, mirrors, and proportion

Through looking at their reflections to create their self-portraits, children have a better understanding of mirrors and reflections. [33]Anne Pelo in *The Language of Art* throws light on the importance of self- portraits and the learning that arises from it when she says, "A self-portrait is an intimate, bold declaration of identity. In her self-portrait, a child offers herself as both subject and artist. When we look at her self-portrait, we see a child as she sees herself." This activity requires children to observe themselves as subjects as viewed in their reflections. It also gives them the opportunity to understand mathematical concepts of ratio, proportion, and symmetry.

Child development: Why is it important to have an integrated curriculum in the early years

In preschool environments, we work towards educating the 'whole child.' [34]It means "attending to cognitive, social, emotional, physical, and talent development of children and youth from widely diverse backgrounds." For children to learn they need to be in a place where learning is possible, where the optimum conditions for survival are met, and these circumstances are best achieved through adopting a Developmentally Appropriate Practice (DAP) — it is an approach taken by early childhood educators. It is grounded

in the research and theories of how young children grow, develop and learn.

The three core considerations of DAP are:

• Knowing about child development and learning.
• Knowing what is individually appropriate.
• Knowing what is culturally significant.

All areas of development (physical, cognitive and social-emotional) and learning are critical, and we need to look at the 'whole child'.

"Mirror, mirror, on the wall…" Creating self portraits

A Picasso inspired self-portrait

CHILD

..

66 *I like the way Picasso draws faces.*
His eyes are funny- they are big and small.
And I like the way he paints the nails. **99**

..

CHAPTER 8

MAX ERNST

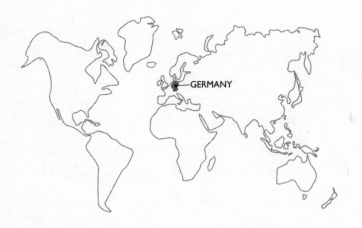

GERMANY

ART TO OBSERVE

Young Man Intrigued by the Flight of a Non-Euclidean Fly[35]

- The science and math behind the activity: Learning about pendulums and viscosity
- Child development: The role of provocation in an early childhood environment; an integrated curriculum in the early years

MAX ERNST was born in Germany. His father who was a teacher motivated Ernst to learn to paint. He developed his unique style of painting, which in fact inspired abstract painters like Jackson Pollock. Ernst described his art as "invention, discovery, and revelation." He experimented with sculpture, painting, collages and also the texture of the paint. He created art with his distinctive drip technique using a pendulum. Instead of a paintbrush, he used either handheld or suspended pendulums to create mesmerizing wave-like patterns. Ernst illustrated this style of art thus: [36]"Tie a piece of string, one or two meters long, to an empty tin can, punch a small hole in the bottom and fill the tin with thin paint. Then lay the canvas flat on the floor and swing the tin backward and forwards over it, guiding it with movements of your hands, arms, shoulders, and your whole body. In this way, surprising lines will drip onto the canvas." If by this time, you have covered the work of Jackson Pollock, you can let the children know that Ernst admired Pollock's art and was profoundly influenced by his drip technique too.

[37]Theodor Pavlopoulos, in his article, *The Mathematics of Max Ernst: The Peacock's Tail* showed how Mathematics influenced Ernst's art powerfully. He stated, "Max Ernst displayed interest in science and mathematics that is certainly traceable in his artistic yield, both on the level of technique and on that of content."

Materials needed

a. Empty water bottle or cup suspended upside down on a string. I usually cut the plastic bottle to create a funnel-shaped cup. To suspend the bottle, I have also used frames from mirrors or A-frames. Some people use a broom or a stick fixed to two chairs.

b. Drill or use a nail to make a hole in the center of the plastic cap. Make sure that it is big enough for paint to drip through.

c. Large sheet of paper to place under the suspended bottle. You can also use an old bedsheet or a large canvas.
d. Tempera paint, slightly liquefied. I usually vary the thickness of the paint.

Set up

a. Place a large sheet of paper on the ground.
b. Suspend the bottle around six inches above the paper.
c. Place liquefied tempera paint in containers on the table.
d. Pour paint into the bottle when ready.
e. Show the child how to swing the suspended bottle above the paper.
f. As the bottle swings, it creates paint patterns on the paper.
g. Use the word "parabola" to describe the patterns that you see.
h. Encourage the child to experiment with the different paints provided, and ask him questions as he is immersed in the process.

The science and math behind the activity: Learning about pendulums, viscosity, and gravity

This art activity takes children through several mathematical and scientific concepts of rhythm, patterns, and motion. Also, it allows children to experiment with the swinging motion of a pendulum to create different parabolic patterns with the paint. Varying the thickness of paint by adding water gives children the opportunity to modify the patterns created by the swinging pendulum.

Possible extensions of this activity:

I would be remiss in writing a book without mentioning Bev Bos, a woman who had so much passion for letting children be messy and have fun. I once attended a workshop where Bev Bos spoke of allowing children to lie down on a tire swing to paint. Once the child was safely on the swing, *face down*, with a paintbrush in his/her hand, the adult would push the swing lightly from side to side. The child would extend his/her hand to the paper placed below to create parabolic patterns with the paintbrush. I've tried this with the kids. I have to admit that it is great fun. The only hitch is that children never want to get off the swing to give others a chance!

Child development: The role of provocations in an early childhood environment

Provocations are thoughtfully set up materials intended to extend and expand the learning of children. Provocations spark new questions and more ideas and invite children to touch, explore and to be curious. It makes the mundane interesting and adds new dimensions to the classroom. In the article *Be Reggio Inspired: Learning Experiences,* the author highlights the very same reasons that I use provocations in my environments. In Reggio-inspired preschools, experiences are set up by teachers with attention to aesthetics, organization, thoughtfulness, provocation, communication, and interaction. [38] Provocations are "deliberate and thoughtful decisions made by the teacher to extend the ideas of children. Teachers provide materials, media and general direction as needed, but the children take the ideas where they want." With 'masterpiece art' activity, I sometimes use materials as provocations: a branch of a cherry blossom to pique children's curiosity or tease their questions.

Painting with pendulums to create Lissajous patterns

Max Ernst inspired pendulum art

CHILD

...

66 These kinds of patterns are in outer space.
I am going to outer space in a rocket ship
to see Mars and the moon.
Maybe I'll meet an alien. **99**

...

CHAPTER 9

WARLI PAINTING

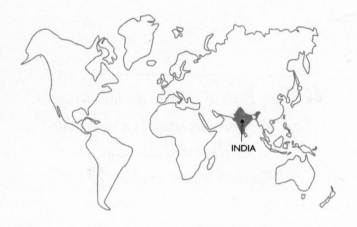

INDIA

ART TO OBSERVE

Warli Painting, Thane District[39]

- The science and math behind the activity: Learning about lines and shapes, circles and triangles; using tools (circle stencils of different sizes)
- Child development: Asking the right questions

THE WARLI STYLE OF PAINTING comes from the Warli tribe of Maharashtra, India. This form of pictorial art can be traced back to the 10th century, where folklore was communicated via pictures to the people in the villages. Most of these paintings depict daily life in the hamlets — scenes of human stick figures engaged in activities like hunting, dancing, and working in the fields, harvesting rice, and grain, etc. Warli paintings are usually done on the mud walls of homes, using rice powder. Thus, the paintings are white in color against a clay or terracotta-colored background. There are very few straight lines in Warli paintings, but there are many concentric circles and spiral patterns.

Materials needed

a. Red-colored poster board cut into 12" x 12" squares
b. Circle or triangle stencils
c. Pencils
d. White crayons or chalk pens
e. Trays or Baskets for the crayons

Set up

a. I usually set the poster board squares on a table along with all the materials easily accessible and ready to go.
b. I show the children pictures of Warli paintings and talk to them about what they see. Here are some open-ended questions that you can ask them:
 1. What shapes do you see in these paintings?
 2. What patterns do you see?
 3. The people of Warli made pictures about their lives in the villages where they lived. If you had to draw a picture to talk about your life, what would it be about?

4. There are lots of circles in Warli paintings. How do you think you can make your Warli style of art with circles and spirals?

c. Encourage children to use the circle stencils to create their spirals or concentric circle patterns. Give them white crayons so that they can create their Warli pictures.

The science and math behind the activity: Learning about lines and shapes, circles and triangles; using tools such as stencils of different sizes, and crayons too

This activity is a perfect introduction to two basic shapes — triangle and circle. Teachers can extend this activity in many ways to scaffold the learning.

a. **Identifying Shapes:** Find all the shapes that you can see in your classroom. Introduce children to quadrilaterals, hexagons, isosceles triangles, etc. that you may see in a classroom (For example, the clock is round or hexagonal. The board is a rectangle). Use math words as descriptors so children will use them too.

b. **Introduce children to two and three-dimensional shapes.** Allow them to explore the similarities and the differences.

c. **Following is my favorite shape extension idea** that [40]Linda Dauksas, director of the Early Childhood program at Elmhurst College and Jeanne White, chairperson of the Department of Education at Elmhurst College, write about in their article *Discovering Shapes and Space in Preschool:* "Create a shape-scape. Teachers and families can collect three-dimensional objects such as cans, cartons, boxes, and balls to create a shape-scape. Children can use cylinders (paper towel rolls) as tree

trunks, spheres (balls) as treetops, and rectangles (cereal boxes) as buildings. Teachers and children can work together to label the shape-scape, count the number of shapes used, and plan additions to the structure." This hands-on activity, which requires a tactile as well as a spatial understanding of shapes, helps children solidify their knowledge of shapes.

Child development: Asking the right questions

[41]The Boston Children's Museum's STEM Sprouts Teaching Guide recommends the simple strategy of building students' confidence and making them feel like experts by asking "what" questions rather than "why" questions. Because the latter implies that there is a correct answer. On the other hand, the "what" questions focus on what the children are noticing and doing, and can be a springboard for teachers and students to investigate together. Here are some questions offered by the Teaching Guide:

- What happened there?
- What did you try?
- What have you changed about what you are making?
- What are some of the ideas you have talked about that you haven't tried yet?
- What have you seen other people trying?
- What do you notice about _____?
- What do you think will happen if we _____?

When children ask questions, (especially the 'why' questions), it can be very tiresome and exhausting. However, it is important to remember their stage of development, and pay careful attention to why they ask so many questions. Questions, and in fact, *more* questions help children in their cognitive development as they cultivate critical thinking skills needed for survival. When children ask questions, in

fact, there is a role reversal of sorts, since rather than being a passive participant children become active participants in learning. That is why it is critical to provide the right questions than 'good' answers when kids ask questions.

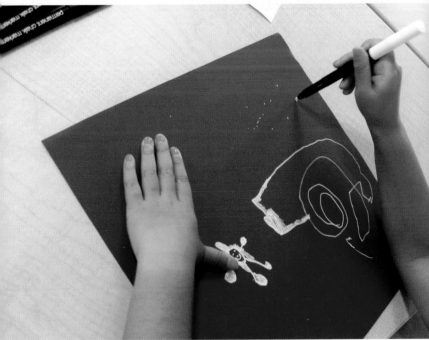

Working with white chalk pens and red paper to create Warli paintings

Warli inspired squiggles and circle pattern creations

CHILD

..

66 *When people go in a circle, they are singing. I like this art because it sings, and people hold hands.* **99**

..

CHAPTER 10

HENRI MATISSE

FRANCE

ART TO OBSERVE
Icarus 1946[42]

• The science and math behind the activity:
Learning about shapes, form, structure and using
tools (scissors)
• Child development: Never draw for a child,
it is a bad idea

HENRI MATISSE was born and raised in France. Although he trained and worked as a lawyer, he realized how much he loved painting, when he had an attack of appendicitis and was confined to his bed. He wrote, "From the moment I held the box of colors in my hands, I knew this was my life." He gave up his career in law to devote his time to art. His work is well-known for the vibrant colors, and the almost liquid-like feel of his paint.

Nearly 40 years later, Matisse was diagnosed with cancer and was confined to a wheelchair. It almost seemed like his career as an artist had come to an end, but Matisse discovered a new way of doing art — by using a pair of scissors. Paper cutouts became his new passion and opened up a wonderful world of cut-out animals, birds, cloudsn and flowers. He used scissors to transform and change the world of 'painting'. "[43]With the aid of Lydia Delectorskaya, his companion, and assistant, he set about creating paper collages, often on an enormous scale, called gouaches découpés (cut collages). By maneuvering scissors through prepared sheets of paper, he inaugurated a new phase of his career."

Materials needed

a. Cardstock paper 8" x 12"
b. Colored construction paper
c. Scissors
d. Glue sticks

Set up

a. Place all materials on the table.
b. Talk to the children about how Matisse used his scissors to create his art.
c. Ask them open-ended questions:
 1. Do collages look the same as paintings?
 2. What do you like about his artwork?
 3. What would you like to create?

d. I sometimes set this activity up as a mural — I tape a large sheet of paper on the wall and have children visually plan their picture.

e. I write their 'plans' on Post-Its. For example, they might say, "I want a wavy blue cloud, and an orange sun, and pink flowers."

f. I then place the Post-Its or paper in front of them and help them gather the papers that they need.

g. Then I give them each a pair of scissors so that they can cut out what they plan to use in their picture.

h. Once they have cut out their material, I give them the glue to stick their colored cutouts onto the card stock paper.

The science and math behind the activity: Learning about shapes, form, structure and using tools (scissors)

When children make collages, there is a multitude of learning that occurs. They learn about form, structure, color, size, and shape of things that they try and represent in their collages. Also, they learn to use space and have a better understanding of proportion. If children can use a pair of scissors, this activity also helps to build the small muscles of the hand.

Child Development: Cutting with scissors

Scissors are fascinating for many children but intimidating for some. Cutting with scissors requires the dexterity of the index and middle fingers and the thumb. Children must also master the ability to separate the hand and the fingers as they open and close the scissors. When manipulating a pair of scissors, children need to isolate the fingers of the hand by putting the thumb into one opening of the scissors, and the remaining fingers into the other. Children need to prepare the muscles of the hand before

they can use scissors. It is important to emphasize that when children lack the confidence to cut with scissors, they may ask an adult to "cut" for them. Never do it, because "cutting" for children means "cutting out learning." I usually give kids a lot of play dough and paper tearing activities so that they can build the muscles in their hands. When adults show children how to use a pair of scissors, it is important to sit *next* to the child so they can copy the hand and finger movements of the adult. It is prudent not to sit across from the child. It is difficult for children to comprehend when someone faces them. Children do not understand the concept of a mirrored orientation. When adults sit alongside, children can see the person next to them, and this orientation helps them figure out what is being modeled to them.

Another aspect that we see in early childhood is hand dominance. Nearly all fine motor activities, including cutting and writing, require a dominant hand (left or right) and a non-dominant hand. Hand dominance, as is stated in an article by blogger Renee, can be seen as early as age three or four, although it may not be firmly established until a child reaches age six or seven[44]. Once a child becomes comfortable with one hand as the dominant hand, the other hand becomes the non-dominant hand by default. While the former performs tasks such as using a pencil or scissors, the latter acts as the stabilizer. For example, one hand holds the scissors when cutting, while the other hand moves the paper. This skill of being able to manipulate a pair of scissors while using one hand as a stabilizer takes time for children. Daily practice helps them become more skilled and aid the muscles get more developed for the next tasks of writing.

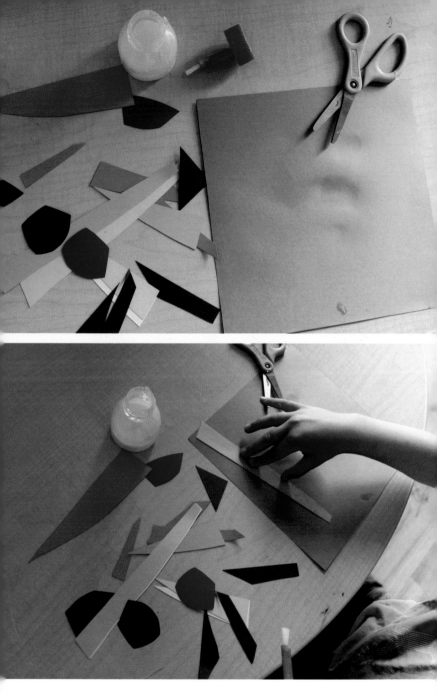

*Painting with scissors: trying to create a Matisse artwork
with paper and glue*

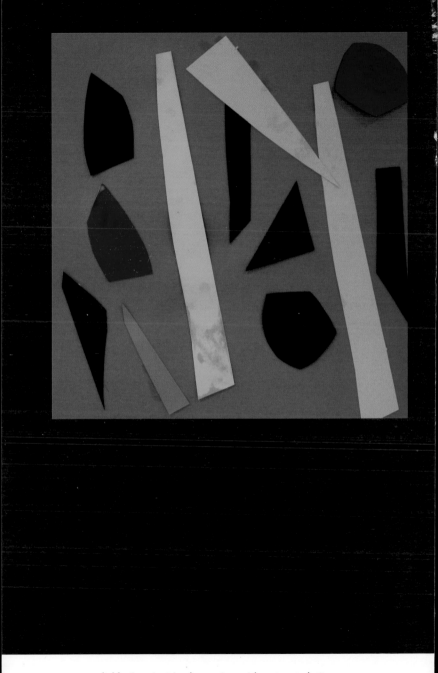

A Matisse inspired creation with cut-out shapes

CHILD

..

66 *These pictures have nice borders.*
When Matisse made big pictures with scissors, it
must be so messy! There would be glue everywhere
on his hands. **99**

..

CHAPTER 11

DON GUYOT

ART TO OBSERVE

French curl on Turkish pattern

by Don Guyot [45]

- The science and math behind the activity: Learning about floating, sinking, and density
- Child development: Praising children's art

DON A. GUYOT was born in Seattle, the USA in 1944. He decided to become a librarian, and so, completed a master's degree in librarianship. He began working at the Seattle Public Library. He enjoyed his work to such an extent that he decided to get a second master's degree in ancient Greek history so that he could become a rare book librarian. This second degree brought him in contact with antique books, and thus his passion and interest for old books eclipsed his job as a librarian. He became a bookbinder in Seattle. When he could not find the papers he wanted to use in his business, he started to marble his paper. So skilled an artist was he that he began to train people throughout the country in the art of marbling and the art of suminagashi, an ancient Japanese technique of decorating paper by floating inks on water — a precursor to the marbling technique of today.

Suminagashi (meaning floating ink) dates back to at least the 12th century in Japan. The artists produced decorative papers by creating bands and wavy patterns of color (usually, on water); they teased and coaxed these floating inks into images using either a thin sliver of bamboo, a hand-held fan or a breath of air. Finally, the image would be transferred onto an absorbent paper and allowed to dry. (You can use a comb, or even a toothpick to get a similar effect. Since it is more the process and not about the product, I don't usually get children to create any patterns unless they want to.)

Children love watching things float. Something is mesmerizing about it. Marbling art appeals to children because of the paint floats on the surface of the water and creates beautiful patterns.

I sometimes bring in as many marbled items as I can so that we can have a conversation about what this might look. I bring a piece of marbled rock, a few printed pictures of Guyot's marbling works, and, for the fun of it, a piece of marble cake!

Here are some questions I have asked of children:

- This artist's style of painting is called marbling. Can you think of why it is called that?
- Guyot created these beautiful pictures by floating paint on water; can we try and make some paint float on water?
- Can you think of other things that can float on water?
- How do you think Guyot created patterns in the water?

Materials needed

a. Watercolor paper. Any paper will do, but if the paper is absorbent, it 'catches' the colors better. The paper should be slightly smaller than the size of the pan.
b. Large pans
c. Water
d. Nail polish. Liquid nail polish works best. Thick or old polish tends to sink to the bottom of the pan. Always have a conversation with the parents if you are going to use nail polish. If they are not happy with the idea, use acrylic paints. I like using nail polish because there's always enough to recycle!
e. Smocks

Set up

a. Fill the shallow trays with cold water.
b. Place nail polish by the side of the tray.
c. Place sheets of paper on the table.
d. Make sure that the children wear smocks before doing this activity since nail polish will stain the clothes.
e. Allow kids to choose the nail polish colors that they want to add to the water in the pan. Help the children splatter the nail polish into the water.

f. Show them how they can make patterns by blowing into the colors in the water. (Tools like toothpicks and combs don't work with nail polish since the nail polish forms a layer of film on the water.)

g. As the polish spreads in the water, engage the children about the colors and patterns that they see.

h. Once the children have created their patterns, help them place the paper in the water to 'capture' the colors on the paper.

i. Help the children remove the sheet of paper, and set it out to dry.

j. You can extend this activity by 'marbling' just about anything: white ceramic tea cups, ceramic ornaments, and animals — follow the same process: drizzle nail polish in the water and let children dip the tea cup or ceramic ornament into the water. Let the paint "catch", and then allow it to dry.

The Science and Math behind the activity: Learning about floating, sinking, density, and surface tension

This activity rests primarily on the principle of surface tension: the property of the surface of a liquid that allows it to resist strong cohesive forces. It allows the paint to float on the surface of the water since the particles or molecules of the paint (or nail polish) are not heavy enough to break the surface of the water. Thus, the colors float on the water and create beautiful patterns. This activity also allows children to explore why the paint drops, create circular patterns and not lines in the water.

Child development: Praising children's art

"What a beautiful picture! Great job!" There is probably nothing more non-descriptive about a child's art than empty praise. [46]As American Alfie Kohn, author and educator, writes in his article about how children are now hooked on praise. They do anything – draw a picture, read two lines from a book, anything, and then they look at their parent in askance: *"Where's my praise?"* Kohn writes, "Hang out at a playground, visit a school, or show up at a child's birthday party, and there's one phrase you can count on repeatedly hearing: 'Good job!' Instead here's what we all can do – ask questions of the child, even if you see only scribbles. 'Tell me more about your picture.' Or, 'I like the shapes that you have created in your picture. I see a triangle here and a circle there…' Or we can say, 'I like the way you have mixed those colors.' It allows the child to describe what he or she has drawn. Sometimes, it could just be a child's free expression, and the drawing may be of nothing in particular. All of this helps a child develop his skills of creating a masterpiece and grow through the process of creating that masterpiece."

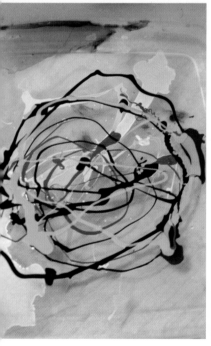

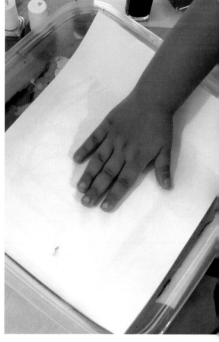

Marbling with nail polish

Children's interpretation of Don Guyot's marbling

TEACHER

..

66 *The paint is floating on water.*
I wonder why it does that? 99

CHILD

..

66 *Have you ever gone swimming?*
Do you wear floats? The paint has floats,
except that they are invisible. 99

..

CHAPTER 12

KILIM WEAVING

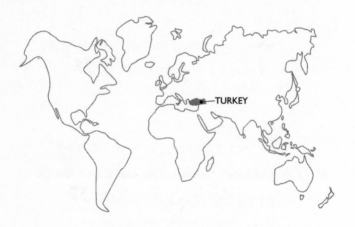

ART TO OBSERVE

Hotamis Kilim[47]

- The science and math behind the activity: Learning about patterns, hand-eye coordination, and colors
- Child development: Why is hand-eye coordination essential in early childhood

THE ORIGIN OF KILIM RUGS goes as far back as 1000B.C in Turkey. In the beginning, these rugs were woven by using animal wool in different colors. Slowly, however, Kilim rugs were made of dyed wool. As the civilization in Turkey began to have domesticated sheep, their weaving grew more sophisticated, and with the invention of the loom, the Kilim rugs began to have more and more intricate geometric shapes.

This weaving activity appeals to children because of how sensorial it is; children enjoy the tactile experience of working with yarn. Also, they love the colors and vibrant patterns that they see in the rugs. I usually bring different kinds of yarn and wool so they can feel the texture of the ones that they wish to use.

Materials needed

a. Paper plates, ruler, and scissors
b. Colored yarn.

Set up

a. Pre- make the underlying grid for weaving on a paper plate.
 1. Use a marker and a ruler to divide the paper plate into 16 "pizza" triangles or wedges.
 2. Cut ½ inch slits on the 16 lines that you have drawn.
 3. Stretch the wool or yarn across the diagonal, from slit to slit to create a line.
 4. Then loop the yarn under the plate to the next slit.
 5. From above, take the yarn across the diagonal to the other side, and then repeat the previous step.
 6. There are great YouTube videos on making paper plate looms. For an illustrated step-by-

step method for making paper plate looms visit this website: **http://bedtimemath.org/paper-plate-weaving**

b. Place the colored yarn and the scissors on the table.
c. I also bring small rugs for the children to see and touch. I encourage them to flip the rug over to examine the back of the rug as well. I talk to the children about the patterns that they might see in the rugs.
d. I show the children the loom and model the "in-and-out" technique of weaving the yarn.
e. I then give them the colored yarn and ask them to fill the plate with 'in and out' yarn.
f. After they have made a few solid colored round rugs I encourage them to plan their next project.

I ask them these questions:

1. How do you think you can make patterns in your rug?
2. How can you get circles that are of different colors?
3. Would you like to add anything to your rugs? (I offer them feathers and beads)

The science and math behind the activity: Learning about patterns, eye-hand coordination, and colors

This activity promotes the ability to distinguish colors. Children also practice their hand-eye coordination and can view shapes and patterns. They discover and create many different types of designs while weaving. I always begin with the simple over-and-under paper weaving, which produces a beautiful "a-b-a-b" pattern that you can extend with the paper plate weaving. [48]Friedrich Froebel, the father of Kindergarten, who, in 1837, started the world's first kindergarten program, developed different types of objects (known as "gifts") to help his kindergartners recognize patterns and appreciate geometric forms found in nature. In addition to his "gifts,"

he also developed a series of occupations such as weaving so that children could reconstruct their daily experiences through play. In the early 1900s, Maria Montessori further advanced the idea that manipulatives (or "materials" as they are referred to in a Montessori environment) are important in education. [49]She designed many materials to help preschool and elementary school students discover and learn basic ideas in math and other subjects. Since the early 1900s, manipulatives have come to be considered essential in teaching mathematics at not just the preschool level, but also at the elementary-school level.

Child development: Hand-Eye coordination

Hand-eye coordination, also referred to as visual motor integration is the ability of the eyes to guide the hands in movements that we make. In young children, this coordination is crucial as it affects their ability to be successful in many areas: drawing, painting or coloring; catching or holding a ball; tying shoelaces or threading a needle; writing and playing with Lego blocks. [50]Recent research conducted by scientists in Indiana University places an enormous emphasis on the role of hand-eye coordination in cognition in early childhood. Author Christopher Bergland writes, "This new research on the role of hand-eye coordination in the early development of toddlers is another clue for practical ways that we can give toddlers and children the best odds for learning, creating social connectivity and lay the neural groundwork for maximizing their potential."

*For Kilim weaving, you need yarn, scissors and
a cardboard weaving loom*

A Kilim inspired masterpiece

CHILD

..

66 *Carpets are soft. I would make a carpet of fur so it would be light, so my carpet would fly.* 99

..

CHAPTER 13

PIET MONDRIAN

HOLLAND

ART TO OBSERVE

Composition with Large Red Plane, Yellow, Black,
Gray, and Blue

- The science and math behind the activity:
Learning about lines, squares, rectangles, and using
tools (scissors)
- Child development: The significance of block play in
early childhood

PIET MONDRIAN was born in Holland where he received formal training in art and spent most of his formative years. He is credited with being the founder of [1]De Stijl, an art movement revolving around abstract works. He moved from Paris to London and then to New York. Picasso's works greatly influenced his abstract art. Mondrian was also inspired by the Cubist style of art. His art is known for its basic forms and the use of primary colors. He is renowned for his unique style of using only vertical and horizontal lines at 90-degree angles to create absorbing art.

Materials needed

a. Large sheet of paper.
b. Rolls of colored tape. Have plenty of these to go around — you will never have enough.
c. Scissors. I encourage children to use scissors independently, and only intervene to support them should they need help.
d. Paint. Make sure that children have the opportunity to choose the paints after they have looked at Mondrian's art. Provide them with the colors that they ask.
e. Bowls for paint.

Set up

Show the children Mondrian's artworks. I enjoy introducing math vocabulary — words like horizontal and vertical — to children. Mondrian's work lends itself readily to this.

Ask kids questions about what they saw: What shapes did you see? How many sides do you see in each figure? What makes Mondrian's shapes so compelling? Then...

a. Pour the paint into containers and set it aside.
b. For this activity, I sometimes ask children to work in pairs so one child can hold the tape, while the other cuts it as required. This activity is always more fun as a cooperative, group effort.
c. Provide each team with a roll of tape and a pair of scissors. Children may need help with the tools.
d. Let them cut the tape into pieces and decorate the paper as they wish. Children love to stretch the tape across the table, and this often becomes a large motor activity.
e. Once they have laid the tape out into different shapes, give them paint to color inside the shapes. Remember, children cannot, will not and should not color between lines, so if the paint goes over the lines, it is okay!

The science and math behind the activity: Learning about lines, squares, rectangles; and using tools such as scissors

Because Mondrian's art is all about lines and angles, this activity allows children to explore and understand straight and parallel lines. It gives children the opportunity of working with tools such as rulers and scissors. This activity can easily be extended to introduce the topic of fractions too.

Child development: The significance of block play in early childhood

Blocks are truly the building blocks of knowledge. According to [51/52]Elizabeth S. Hirsch, author of the *Block Book*, "Cognitively, children learn math and science through experiences with block size, shape, and volume, and learn language through expressing their thoughts during block building sessions." Block play, in her opinion, helps in the

overall development of young children in all three domains of development: physical, cognitive and social-emotional. They learn to share ideas and blocks with each other, sometimes building structures cooperatively; they hone their fine motor skills as they build with the blocks, and understand the theories of balance and symmetry as they build complex structures using blocks. Also, self-regulation is required to remain part of the group. They use their small motor muscles as they balance each block on top of another and as they build either vertically or horizontally. They learn about height, length, measurement, shape, and concepts like 'same as', and 'more than' or 'less than.' Building sculptures offer children the opportunity to learn about, explore, understand, and experiment with the idea of three-dimensional designs.

*Working with tape and paper to create Mondrian
inspired artwork*

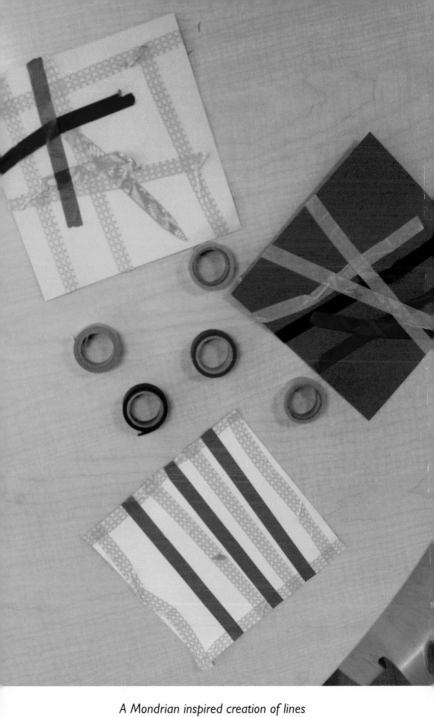

A Mondrian inspired creation of lines

..

66 *This is a hockey field. Let's put tape on the field. Now let's cover up the field with paint.* **99**

..

CHAPTER 14

BYZANTINE EMPIRE MOSAIC

EASTERN ROMAN
BYZANTINE EMPIRE

ART TO OBSERVE

Mosaic decoration with a fountain[53]

- The science and math behind the art: Learning about patterns, shapes, geometry, and how many parts make a whole
- Child development: Why water play is good for children

BYZANTINE ART is the name given to the art of the Eastern Roman Byzantine Empire. Mosaic refers to the decoration of a surface (vases, artifacts or flat surfaces such as floors) with designs made up of colored, small pieces of materials such as pebbles, semi-precious stones, shells or glass. Mosaic patterns were used to decorate floors and also walls or icons (different colored materials were used in varied manner to create paintings — small gray pebbles or marble, or rock were used for hair; pearl or shell for skin or clothing. Figures of humans were often set against a shiny, glimmering background).

I always show the children photographs of mosaics, and if possible, I bring in an artifact with mosaic on it. I then talk to the children about what they see:.

1. What patterns do you see in these mosaic pictures?
2. Do you see anything else in them? Do you see figures or shapes?
3. What do you like about this style of art?
4. How many small pieces of stone would you estimate makes up this picture?
5. This artist created a mosaic on a wall; what problems do you think this artist might have had to solve?
6. What can you do with these tiles?
7. Which shape can be made by using other smaller tiles?
8. Using the principles of doing tangrams, you can also ask children, "How many ways can you make a square (or another shape) from some or all of the tiles?"

Materials needed

a. A wooden board or thick cardboard for the base. I pick smaller bases, so children are not overwhelmed by how slowly this project grows. I find an 8" x 8" size to be just right for their little fingers.
b. Mosaic tiles
c. Glue
d. Bowls

Set up

a. Place wooden base on the table. I always explain to children that mosaic artists had to plan their work so that they had a picture in their mind's eye. I encourage them to draw out their ideas on paper.
b. Place mosaic tiles in bowls. Once they have their plan and have assigned colors to the shapes, I encourage the children to separate the tiles according to colors in different containers.
c. Place glue on the table. I use thick all-purpose glue for this. This activity requires children to exercise their fine motor muscles and their pincer grasp.
d. Towels for cleanup. I always have a wet towel available to wipe hands, since their fingers get sticky as they place each tile on the surface.

The science and math behind the art: Learning about patterns, shapes, geometry, and how many parts make a whole

More than anything, a mosaic activity helps children learn geometry in a developmentally appropriate way using the [54]*van Hiele Levels of Geometric Thought*. According to this thought, "deliberate instruction is needed to move children through several levels of geometric understanding and reasoning skill." Pierre and Dina van Hiele put forth a theory

on the hierarchy of geometric thought. These are the levels that we look at in early childhood.

1. **Level 1:** This is a 'nonverbal thinking' stage. Shapes are judged by their appearance and viewed as a whole, rather than by distinguishing parts
2. **Level 2:** This is a descriptive stage where children can identify and describe the components and properties of shapes.
3. **Level 3:** Informal deduction. In this stage, children see that the properties of shapes are logically ordered.

Child development: Why water play is good for children

Water play is good for children's physical, cognitive and social-emotional development. Sensory play of this sort is open-ended: there is no right or wrong play with water. It lends itself to thousands of possibilities, and all children can be successful at this activity. Free play with water can build the foundation for understanding

- Physics (words like fast, slow, and flow)
- Chemistry (solutions, floating, and sinking)
- Biology and ecology (water conservation, drought, plant, and animal life)
- Mathematics (empty, full, heavy, and light, measurement, and volume).

Children learn about the world through their senses: touch, taste, smell, sight, and hearing. The sensory play also contributes in crucial ways to brain development. So, providing a variety of sensory experiences including water that piques their curiosity is essential because infants and young children thrive on sensory stimuli. Science is "serious play," and it is indeed everywhere around us. Carol Gross, in her article, *Science Concepts Young Children Learn through Water Play* states "What can children do to increase their

understanding of science? Everything! [1]Children inquire, observe, compare, imagine, invent, design experiments, and theorize when they explore natural science materials such as water, sand, and mud. Through water play, children learn about concepts like empty/full, before/after, shallow/deep, heavy/light, float, strain."

Looking at shapes in mosaic tiles: working with squares

A Mosaic masterpiece

CHILD
·······························

66 *You really have to be careful to glue this because, with stones, the glue is so drippy. Small rocks fall off all the time.* **99**
·······························

CHAPTER 15

..

BANDHANI — TIE AND DYE

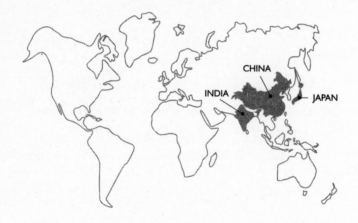

ART TO OBSERVE

andhani art from Rajasthan/Gujarat [55]

~~~~~~~~~~~~~~~~~~~~~~~~~~~~~~~~~~~~~~~~~~

• The science and math behind the activity: Learning about patterns, color diffusion, and color mixing
• Child development: Why choice is pivotal

THE ART OF TIE-DYE began in the east and later developed in India, China, and Japan. The word bandhani comes from the Hindi word *bandhan*, which means "to tie something" or a "knot." This style of art thrives in the Indian states of Rajasthan and Gujarat. The art form dates back to almost 5000 years when the dyes were not synthetic but organic and plant-based; extracted from roots, flowers, leaves, and berries. Creating bandhani designs involves a few steps. First, the fabric (usually cotton) is tied with a cotton thread at certain pre-determined spots to form a pattern. It is then dipped into organic dyes. Once dry, the knots are removed, and the fabric reveals intricate circular patterns, as the dye does not penetrate the 'tied' parts.

I show the children scraps of bandhani fabric and also pictures of bandhani. While looking at the vivid colors of this art form, I usually ask children the following questions:

1. What do you like about this style of art?
2. How do you think we can make colors mix like this?
3. Do you like the patterns that the colors create?
4. Why do you think that this style of art creates many round designs?

## Materials needed

a. Sharpies. I encourage the children to choose the colors they like to paint on the fabric. I tell them that when the people of Gujarat and Rajasthan make their bandhani art, they color the material in bright hues.

b. White fabric cut into 12-inch squares. You can use larger pieces, but make sure to have a sturdy base for children to color. Even piece of cardboard can offer the right kind of support for coloring.

c. Isopropyl alcohol. It is available as wipes and also in the form of liquid. I usually purchase liquid isopropyl alcohol so that the children can use droppers to measure the amount of liquid that they wish to use.

d.   Small containers
e.   Droppers
f.   Plastic or cardboard to place fabric on

## Set up

a.   Fill containers with the isopropyl alcohol. If possible use spray bottles as they seem to work better with children. Always remember to have a stringent one-to-one ratio when working with materials such as isopropyl alcohol.

b.   If using containers or bowls for the alcohol, then place droppers next to them.

c.   Place fabric squares on cardboard or plastic. Since fabric tends to slip, I usually attach it to a clipboard on one side, and use large binder clips on the other end to keep the fabric on a rigid surface, stretched and taut.

d.   Place sharpies on the table.

   1.   Encourage the children to draw on the fabric with the sharpies. Show them how to fill the space with color.

   2.   Once they have finished coloring the fabric, put away the sharpies.

   3.   Give children the isopropyl alcohol with the droppers, and ask them to see what happens when they add drops of alcohol to the colored fabric.

   4.   When the alcohol comes in contact with the colored sharpie art, the ink dissolves to create tie dye patterns.

## The science and math behind the activity: Learning about patterns, solubility, absorption, color diffusion, and color mixing

Children explore properties of soluble and insoluble substances when working on this art project. They realize that the ink in permanent markers and sharpies can dissolve in the alcohol, resulting in the diffusion of color on the fabric. As a variation, I also give children bottles of water with droppers. Children realize that the ink in permanent markers is not water soluble. (Children enjoy this activity so much that you may need many extra squares of fabric.)

## Child development: Why choice is pivotal

Research shows that children are more cooperative, interested and focused when they are involved in activities where they have a choice. Having to make a choice gives children autonomy in decision making, and also allows them to own responsibility for their choices or actions.

[56]Sue Grossman, in her article *Ofering Children Choices: Encouraging Autonomy and Learning While Minimizing Conflicts* quotes research by Fromberg and Maxim, when she states, "Children feel more committed to an activity they have chosen themselves. Therefore, their attention span will likely be longer if they choose an activity than if they work at a task assigned by the teacher. Making choices helps children learn persistence and task completion."

*Tie-dye with sharpies and isopropyl alcohol*

*Children's Bandhani inspired art*

CHILD 1

..................................................

66 *I like pink and purple mixing.* 99

CHILD 2

..................................................

66 *Me too.* 99

CHILD 3

..................................................

66 *Me too.* 99

CHILD 1

..................................................

66 *We're triplets.* 99

# CHAPTER 16

# BATIK

INDONESIA

## ART TO OBSERVE

### *Indonesian Batik*[57]

- The science and math behind the activity: Learning about heat, melting, cooling, and physical change
- Child development: Why children need to work with real tools

BATIK is an Indonesian-Malay word that refers to a unique process of dying fabric, parts of which may have layers of wax applied to it. This art is thought to be over a thousand years old. Artists usually draw designs on cotton or silk material using dots and lines of hot wax, after which the fabric is then dyed. This step is repeated with several colors and layers of wax to create the final 'picture.'

Children are fascinated by 'change' and this activity mainly appeals to them since they see the fabric change before their eyes. Another aspect of this activity that's alluring to young children is the element of risk taking: this art requires that children work with hot wax. While it is indeed thrilling to do so, it is crucial to maintain all safety parameters. I work with the children one-to-one basis thus mitigating any possibility of risk.

## Materials needed

3-5-year-olds

a. Wax crayons. (You can place a sheet of aluminum foil on the griddle, and then position the piece of fabric on the foil. Let the children draw directly on the fabric. Again, make sure to maintain a strict one-to-one ratio while doing this activity.)

b. Paintbrushes

c. Metal cupcake tin (this is required for the most advanced version of the art where children will paint with hot wax paint.)

d. Deep pan for hot water. I sometimes microwave the crayons. The issue with this is that you will have to heat it frequently since the crayons solidify quickly.

e. Electric Griddle or Hotplate (need to plug it in)

f. Small squares of fabric

g. Cold black tea. I use black tea instead of dye. It is safer for children to use.

## Set up

This activity requires a multi-step setup and stringent one-on-one ratio. I use an electric griddle with the children, and always make sure to let them know how to behave with such equipment. This activity also takes a few days, so remember to space it out.

Before starting the activity, I show children either real pieces of fabric or pictures of batik so they can see what it looks.

I ask them questions to help them appreciate this art form and to engage their curiosity:

- What do you see in these pictures?
- What do you like about these pictures?
- Do you like the way the colors have black lines in them? Can you think of how those black lines can be made?

## Crayon Resists: for younger children

1. For the younger children, I usually walk them through the process of making simple crayon resists.
2. Provide the children with paper and crayons.
3. Once they have completed their picture, provide them with black watercolor paint to paint over their pictures.
4. The colors magically appear on the paper, creating a colorful batik picture where the "empty" spaces (where there is no crayon impression) is black.

## Hot wax melting or hot wax painting: for older children

a. I plug in the electric griddle before starting the activity at a place where children cannot reach. Once I am ready with the other material, I bring the electric griddle to a table where children can reach.

b. When ready, place a deep dish with hot water on the electric griddle.

c. Give the children bits of crayon so that they can remove the paper covering. It can be done in advance.

d. Once you have the bits of crayon, sort by color in the sections of the metal cupcake tin. Please note that this tin will be unusable in the kitchen after this activity.

e. Place fabric and paintbrushes on the table. I make sure to affix the fabric to a wooden clipboard or a thick piece of cardboard so that children can paint on it easily without the fabric slipping.

f. Have Ziploc bags with black tea available.

g. Once you are ready, place the metal cupcake tin with the crayons in the pan of hot water. Talk to the children about what they see as the crayons begin to melt to form a thick waxy paint. You will need at least 3-4 crayons of each color that you decide to use.

h. Let the child paint with the melted wax paint.

i. Once the picture is painted, crush the fabric into a tight ball, and place in a Ziploc bag with some black tea. Remember, to add *cold* and not hot tea to the fabric. Dry the material. Now, you have to remove all the wax from the fabric. The best way to do this is by sandwiching the fabric between layers of newsprint or a thin towel. Then iron on a medium setting. It is a multi-step activity spread over many days. Make sure that every day ends with a recap of the step that was completed and the science behind the activity.

## The science and math behind the activity: Learning about heat, melting, states of matter, cooling, and physical change

This activity is an excellent introduction to the three states of matter: solids, liquids, and gasses. Through the process of making the batik pictures, children will have the

chance to see how, when heated, solids become liquids, and how, upon cooling, liquids become solids again. I always introduce this topic with some lead questions so that they are familiar with the words: heating, cooling, and change.

I usually take some cubes of ice, and if permitted, even some ice cream. (If you do that, make sure that you have some for the children to eat; it's too cruel to let them watch the ice cream melt melt!) I leave the ice or the ice cream on a plate, and talk the children through the process of observation, and hypotheses: What is happening to the ice? Do you think that it is a solid? Is it still solid? What can we call it now that it is melting? What will happen to it if we put it in the fridge? Shall we try? Once they are familiar with the states of matter and the process of melting and cooling or freezing, I then introduce the art of batik to them.

## Child development: Why children need to work with real tools

Children love using actual tools. They learn through observation and any preschool educator or parent knows the fascination a child has with physical tools. They watch curiously as the plumber fixes the sink or as a parent wields a screwdriver. This is why I seldom give children plastic replicas of tools — it doesn't teach them anything. However, it does allow them an opportunity for dramatic play. I give children real tools because I believe in their ability to use tools safely. Of course, as with anything else that might cause accidents, it is imperative to lay down the ground rules for safety: what they can or cannot do; how they handle the tools, etc. I love what [58]Aunt Annie writes in her blog about respecting children: *"Children are capable beings, and if we respect their capabilities we will very often be amazed by what they can do. Offering them real tools is a way we can show this respect. They like to be involved in decisions that affect them. Involving them in making and keeping safety rules is a way we can enhance this relationship, as well as looking after their welfare and helping them develop risk assessment skills."*

*Working with hot wax: making crayon resist pictures*

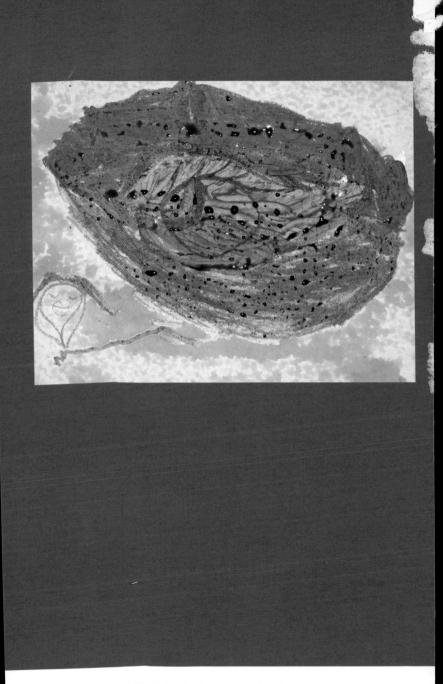

A Batik inspired crayon resist picture

**CHILD**

......................................................

66 *When you put hot air on it, it melts like ice. And then it rains colored water.* 99

......................................................

# CHAPTER 17

# M.C. ESCHER

ITALY

ART TO OBSERVE

*Pegasus No. 105*[59]

- The science and math behind the activity: Learning
about patterns, repetitions, and tessellations; using
tools such as rulers and stencils
- Child development: Real math in a
preschool environment

M.C. ESCHER was born in Italy where he lived for most of his life. He went to school to study architecture but realized that he loved graphic art more. Many of his prints, lithographs and woodcuts show his passion for architecture, with his unique sense of perspective and a mind-boggling representation of impossible space. He is rightly regarded as the father of tessellations. The word itself comes from the Italian expression, *tessera*, meaning 'small stone'. Escher created tessellations or works of art where a shape is repeated over and over again without any gaps. He was so obsessed with his art that he is known to have stated, [60] "Filling two-dimensional planes has become a real mania to which I have become addicted and from which I sometimes find it hard to tear myself away."

This style of art resonates with children because they love using stencils to draw. By the age of three, children begin to explore using stencils, and by age four, many are quite adept at using them — they use one hand as a stabilizer and the other to draw around the stencil.

I like to talk to the children about tessellations and to draw their attention to it in their real life. When possible, I bring in physical objects like soccer balls, chess or checkerboards or quilts that I may have, to illustrate tessellations. I let children manipulate the ball, or examine the board or the quilt to understand that the shapes of these items have two features:

1. They repeat
2. There are no gaps or overlaps

## Materials needed

a. A4 size paper — either on a clipboard or taped to the table.
b. Stencils — either made by the children or store-bought ones
c. Color pencils or markers

## Set up

a. Place all materials on the table. If I see children struggling with the coordination of their hands while working with stencils, I tape the paper down for them.

b. I usually use a word wall to explore the shapes they think might "repeat" and "not overlap." Once they decide on the shapes or forms they want, I do one of the two things: if the children can draw using a ruler and cut with scissors, I let them draw and cut out the shape they want. If they are not yet adept at using those tools, I provide them with shape stencils.

c. Encourage children to use the stencils to create shapes on the paper.

d. Show them Escher's tessellations and explain that Escher would make his shapes "*touch.*"

e. Tell them to fill up the sheet of paper with the shapes, each shape touching another.

f. Once they have created the shapes on the paper, ask them if they would like to color them.

g. Provide the kids with paint, markers or crayons to color the shapes.

## The science and math behind the activity: Learning about patterns, repetitions, and tessellations; understanding the concept of space and using tools such as rulers, scissors, and stencils

This activity is ideal to introduce geometry to a child. Children can explore the three kinds of polygons (square, triangle, and hexagon) which have the property to tessellate. They will also have the chance of using tools to enhance their understanding of polygons and tessellations.

## Child development: Real math in a preschool environment

Smita Guha, in her article for NAEYC, *Integrating Mathematics for Young Children through Play*, states that young children who learn number concepts and other mathematical knowledge through hands-on play activities and discussions gain a broad understanding of math skills. Real math in preschool environments is not so much about learning math, as it is about practicing and using it in everyday play.

Math has many dimensions, all of which are explored in the preschool environment. [61]Kristin Stanberry, in her article, *Early Math Matters: Preparing Preschoolers to Succeed* lists the five dimensions of math that should be explored in every preschool classroom. They are:

1. Number sense
2. Geometry
3. Measurement
4. The language of math
5. Spatial relations

In an excellent preschool program, rather than 'teaching' math to young children, teachers should strive to make math real for young children. It would mean having many conversations using math language — for example, using numbers, words like miles or kilometers, pounds, and kilograms. It also means creating opportunities in an environment where children explore mathematical ideas and expand their learning. Provide math tools like tape measures and weighing scales so that when children have opportunities to test their hypotheses, they have the necessary instruments to extend their learning. When they build tall towers with blocks, ask them how tall they are. Give them tape measures to figure out the height. Encourage the usage of words like *"taller than…equal to…"* As Stanberry rightly comments, "There's every reason to believe that today's preschoolers can

grow up to understand, experience and appreciate math in a broader and more practical context than the generations before them."

*Trying to create Escher inspired tessellations*

*Trying to create Escher inspired tessellations*

CHILD

..........................................................

66 *I like patterns; they fit like a puzzle.* 99

..........................................................

# CHAPTER 18

# ABORIGINAL DOT ART

AUSTRALIA

## ART TO OBSERVE

### *Ngurrapalangu*[62]

- The science and math behind the activity: Learning about shapes, proportion, and the use of tools (Q-tips)
- Child development: Why creativity is important in early childhood

ABORIGINAL ART epitomizes abstract art — an amalgamation of strange shapes and outlines, bordered by a series of dots. The truth is that original native art was never meant to be communicated to the westerners, and thus was never a permanent installation. The art or the communication was often painted on people, or on sand, so it could be either washed away or smoothened out so no one could understand the hidden message. However, with the passage of time, a teacher of Aboriginal children, Geoffrey Bardon, encouraged the Aborigines to start putting their art on canvases, so the world could know and appreciate their way of communication. The Aboriginal people began to draw on canvases and substituted their sacred elements with dots, so that while they could share their art with the common man, the messages that they held as sacred would remain theirs forever. This art style resonates with young children, as all art begins with a series of scribbles before it advances to the most basic shape — a dot.

## Materials needed

a. Colored construction paper
b. Strips of colored glaze paper cut into waves
c. Glue sticks
d. White paint
e. Q-tips
f. Bowls for paint

## Set up

a. Pour the white paint in bowls.
b. Place Q-tips in the bowls.
c. Place all other material on the table.
d. I show the children the prints of aboriginal art and ask them what they see. We focus first on the base colors.

e.  I ask the children to pick out the color of the paper that they would like to work with. And I give them their choice of construction paper to use as the base for their art.

f.  Once they have their base colors decided, we talk about how the Aboriginal artists "enclosed" shapes and spaces. I then give them different wave patterns that I cut out of the glazed paper so that the children can work on enclosing areas to create shapes and patterns. If the children are adept at using scissors, then I let them cut the wave-patterns out on their own. As far as possible, I do not cut out shapes for children. Remember that younger children can tear the paper quite skillfully.

g.  I then give the children glue sticks so that they can create their shapes with the colored wave paper.

h.  Once this is done, I encourage them to look at the samples of Aboriginal art, and at the dot patterns.

i.  I tell the children that they too can create the dot markings if they want, by using Q-tips, or any other tool that they wish to use.

j.  Once their work is complete, I ask the children to dry it on the drying rack.

## The science and math behind the activity: Learning about shapes, proportion, and using tools (Q-tips)

The exercise of filling a blank paper with shapes requires children also to understand the concept of size and proportion. When children explore forms and understand space in a two-dimensional context, they are, in fact, immersed in the process of mathematical research. [63]Ann.E Epstein, in the book, *The Intentional Teacher: Choosing the Best Strategies for Young Children's Learning*, highlights the importance of this kind of math exploration: "The goal of early mathematics education, then, is to build mathematical power in young children. This power has three components:

a positive disposition to learning and using mathematics; understanding and appreciating the importance of mathematics; and engaging in the process of mathematical inquiry."

## Child development: Why creativity is important in early childhood?

Young children have a natural inclination towards out-of-the-box thinking. In their minds, everything is possible. Yes, dragons can exist. And yes, they can build a giant tower with Lego blocks, and they can fly to the moon in a cardboard rocket ship.

When we think of creativity in an early childhood environment, we think of things that children create. We think of products, not the process. Creativity, unfortunately, is given the least importance as children grow and develop. As Sir Ken Robinson says, "We concentrate on developing children's brains, thus reducing the rest of the body into mere vehicles that transport the minds." We spend the early years teaching young children the alphabets and numbers. The reality is that creativity lies not in the actual products that children create, but rather in the process the children go through to create those very products. Often those products are not even tangible. In fact, many times, the product is an *idea*.

Author Simon Sinek writes, "What good is an idea if it remains an idea? Try. Experiment. Iterate. Fail. Try again. Change the world." In a child's world, an idea can, in fact, remain an idea as long as it goes through a process that is scaffolded by the teachers and adults around them. It also passes through the procedures of trying, experimenting, iterating, and maybe even failing. As preschool teachers, and as parents, we often use language to stretch children's curiosity, reasoning ability, creativity, and independence. We do this by asking open-ended questions, which have no single right or wrong answer. Instead of predictable "yes"

or "no" responses, open-ended questions (name an animal with a trunk; do penguins fly?), elicit fresh and sometimes even surprising insights and ideas, opening children's minds. They have a lot to say most of the time, and it is important to listen attentively to their responses. It also gives adults the opportunity to extend the conversation, and also to draw more about the topic. This tell-me-more-approach is crucial as a child is learning new words and building his/her vocabulary. An adult's attitude of *"tell me more"* acts as a springboard to help a child's creativity flourish and thrive.

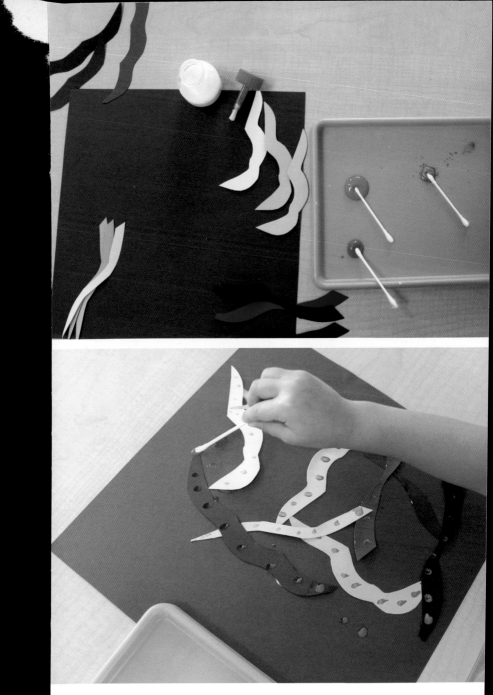

*Creating dot art with paper, paint and Q tips*

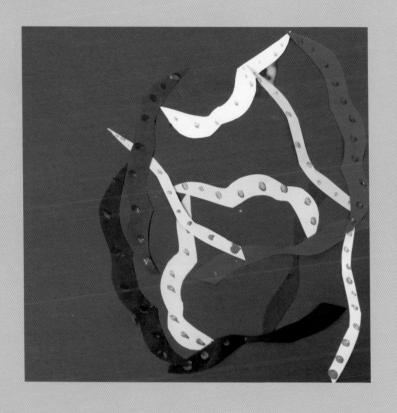

*An aboriginal inspired masterpiece with dots*

CHILD

..............................................

**66** *I like dots and patterns;*
*they look like rainbows. And they're so little,*
*like my baby brother.* **99**

..............................................

# CHAPTER 19

# KATSUSHIKA HOKUSAI

JAPAN

## ART TO OBSERVE

### *Cherry Blossoms*[64]

- The science and math behind the activity:
Learning about seasons, parts of trees, structure, colors,
scent, symmetry and using tools (cotton wool)
- Child development: The need for the outdoors
in early childhood

KATSUSHIKA HOKUSAI was a Japanese artist and printmaker. Surprisingly, he was a master in the art of Chinese painting. His father was a mirror maker, who often embellished the mirrors with paintings. Having watched his father at work from an early age led, Hokusai took to art when he was only six years old. He became an accomplished artist. In his later years, Hokusai concentrated on painting landscapes, and also detailed images of flowers and birds.

## Materials needed

a.  Large sheet of paper
b.  Branch of cherry blossom. If you cannot get one, then show children pictures of cherry blossoms and the cherry blossom paintings by other Japanese artists.
c.  Paint. I usually let the kids tell me what they see, and what colors they think we should use. If they say, "pink", then we make the pink paint together. Thus, his activity also involves color mixing.
d.  Cotton wool balls
e.  Cut out branches or twigs

## Set up

a.  Pour the paint into containers. Children may ask for colors that the adult doesn't see. Always be prepared to provide children with the colors they ask for.
b.  Place cotton balls in bowls for the children to use.
c.  Talk to the children about the cherry blossom tree.
d.  Show them as many pictures as you can of the tree in bloom and the tree in the fall, when it is bare and without leaves.
e.  If possible, bring a real branch for the children to see and touch. (I bought a plastic branch with silk flowers online. They are also available at certain craft stores.)

f.  Help the children describe the flower. Use as many words as you can to describe it: petals, colors, etc.

g.  Tell the children that you found a branch and you brought it to see if they could create a Hokusai-like picture of cherry blossoms.

h.  Help them affix the branch to the cardstock paper.

i.  Ask for their input on the colors they need for the flowers.

j.  Tell them that they will be using a tool to create the flowers — cotton balls to make paint impressions. If they ask for other instruments, try and provide them as well.

k.  Once the children have created their flowers using cotton balls dipped in paint, place the cardstock picture on a table to dry.

## The science and math behind the activity: learning about different parts of trees, seasons, colors, scent, symmetry, structure, and using tools (cotton wool)

I tend to focus on investigations and questions about trees, as outlined by the [65]website, massaudubon.org.

1.  What are the parts of a tree?
2.  How does a tree grow?
3.  How does a tree make pinecones or acorns?
4.  Why do leaves change color in the fall?
5.  Who lives in trees?
6.  How do trees help us?
7.  Why do some trees have leaves in the winter and some do not?

I use a word wall and write down as many tree words and facts as possible. If you can, take the children outdoors to touch and see an actual tree. This way they get to explore the bark and texture of a tree, carefully examine the leaves and flowers of a tree and have a better understanding of the parts of a tree.

## Child development: The need for the outdoors in early childhood

We think of the outdoors as something that offers children only physical and motor benefits. It could not be further from the truth. Children are developing in every way possible: physically, socially, emotionally, and even cognitively. Preschoolers learn much through their senses, whether indoors or outdoors. In their environment, they get to touch things and learn through their tactile sense; it might be a squishy ball of play dough or a crinkly dry leaf. They get to hear different sounds – of nature, of birds calling, of thunder rumbling in the sky or the sound of the gentle pitter-patter of rain. They get to taste things (sometimes, they don't like how it tastes!). These sensory experiences cannot be replaced by the technology of today. According to celebrated child development author, [66]Rae Pica, "Children who spend a lot of time acquiring their experiences through television and computers are using only two senses (hearing and sight), which can seriously affect their perceptual abilities."

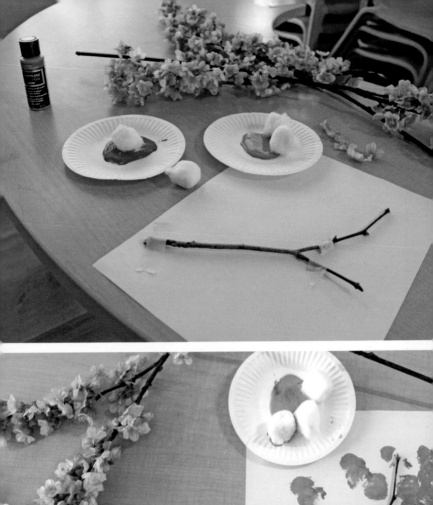

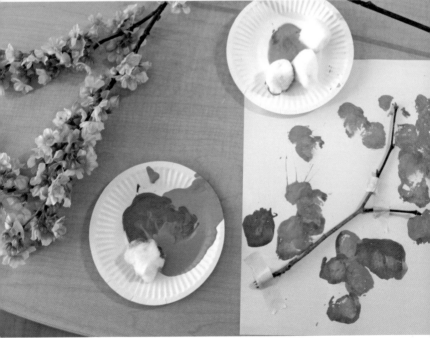

*Looking at cherry clossoms and creating blossoms with paint and cotton wool*

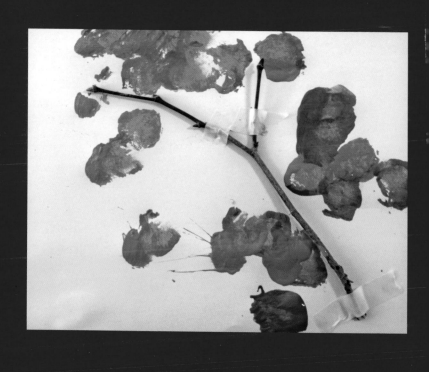

*A Katsushika Hokusai inspired masterpiece*

CHILD

.....................................

66 *Trees are so special - they give away paper!* 99

.....................................

# CONCLUSION

The process of looking at masterpiece art brings the subject under a singular focus. When we look at learning through the lens of constructivists like John Dewey, we realize that children construct their understanding and knowledge of the world through hands-on experiences.

[67]Professor George E. Hein at the International Committee of Museum Educators Conference in 1991 outlined the main tenets of this theory as it relates to young children's learning:

1. Learning is an active process in which the learner uses sensory input and constructs meaning out of it.
2. People learn to learn as they learn. It consists of both constructing meaning and creating systems of meaning.
3. The significant action of creating meaning happens in the mind.
4. Learning involves language. And the language we use influences learning.
5. Learning is a social activity. Our learning is intimately associated with our connection with other human beings.
6. Learning is contextual.
7. One needs the knowledge to learn.
8. It takes the time to learn as learning is not instantaneous.
9. Motivation is a fundamental component of learning.

Teachers who immerse a child in the scientific process by looking at the works of great artists base their teaching on the principles of constructivism.

What we see in preschool classrooms today is a paradigm shift. Teachers are moving from pre-planned or canned curricula to thoughtful and intentional instruction. The modules are now more emergent and based on the interests of the children in their care. Tutorss have moved from whole group instruction to working with children in small, focused groups. Since time immemorial, educators have focused on lesson plans for their teaching; we now have moved from lesson plans to process plans. The focus is on how children learn rather that what they learn.

Classrooms are not the same anymore. There is less of the desk-chair arrangement in preschool, and more of inviting spaces, filled with provocations. The most important feature that we see is the shift from being "time-bound" to being "space-bound." Teachers emphasize less on the class being divided into 45-minute slots and instead, have embraced activities and interests.

As [68]Loris Malaguzzi, credited with being the founder of the Reggio Emilia way of thinking stated: "The pleasure of learning, of knowing, and of understanding is one of the most important and basic feelings that every child expects from the experiences he confronts alone, with other children, or with adults. It is a crucial feeling, which must be reinforced so that the pleasure survives even when reality may prove that learning, knowing, and understanding involve difficulty and effort. It is in this very capacity for survival that pleasure is transformed into pure joy."

This book is intended to do just that — help teachers bring the pleasure of "learning and knowing" back into the classroom. It is not meant to be a merely 'How to' book, which focuses on the work of 19 artists. It is a book that opens windows into different ways of looking at masterpiece art.

Here is a simple flowchart that can be used to incorporate the works of other artists that a teacher may want to use.

Very often material that is found in a science center never finds its way to the art area, but the truth is, material that inspires curiosity and scientific thought need not be confined to area specific centers in a preschool environment. Articles that can be used to explore one concept can overlap other areas too. Here is a list of items that can help children explore art, science and math concepts:

| What you see in an artist's work | Material | Science & Math concept explored | Art that you can do |
|---|---|---|---|
| Circles | Balls, Marbles | Gravity, incline | Painting with bouncing balls, rolling marbles |
| Color blends | Pipettes | Liquids | Colors, color diffusion, color mixing |
| Round patterns, circles | Cardboard tubes | Rolling, inclines, shapes, three-dimension | Circles, patterns |
| Color blends | Magnets | Attraction | Colors, color diffusion, color mixing |
| Self-portraits, faces | Mirrors | Reflections | Self-portraits |
| Color blends and color mixing | Wax crayons | Melting, physical change | Colors, color diffusion, color mixing |
| Color blends and color mixing | Ice (with color) | Melting, physical change | Colors, color diffusion, color mixing |
| Color blends and color mixing, layers of paint and other media | Waterproof ink, pens or permanent markers | Soluble and insoluble, floating and sinking | Resist Paintings |
| Color blends and color mixing, layers of paint and other media | Nail polish | Soluble and insoluble, floating and sinking | Marbling |
| Collages, mixed media | Scissors | Shapes | Collages |
| The concept of chiaroscuro in art | Flashlights | Shadows | The concept of chiaroscuro in art: darkness and light |
| Fresh flowers, real trees, real insects portrayed in still-life paintings | Plants and flowers | Living things | Still life art |

| Color blends and color mixing | Electric griddle or hot plate | Melting, heat | Colors, color diffusion, color mixing |
| --- | --- | --- | --- |
| Color blends, color mixing, layers of paint and other media | Grater | Many parts make a whole | Collages |
| Circles, round shapes, patterns | Plunger | Vacuum | Painting circles |
| Drip or splatter art | Sieves, strainers | Solids, liquids | Splatter painting |
| Color flows or drips lines | Fan- handheld or drinking straws | Motion, the wind, air | Colors, color diffusion, color mixing |
| Color blends and color mixing, layers of paint and other media, round shapes, patterns and tessellations | Bubble wrap, sandpaper | Texture, sensory learning | Painting with different textures |
| Geometric shapes | Ruler, compass, protractor | Tools, measurement, shapes, lines | Drawing shapes |

# AFTERWORD

Great mentors understand grand ideas. They master ideas by implementing them. And that is what Jayanti has done with *The Art of Math and Science*. Very rarely we have books evolving out of the understanding of the importance of art and its acute need. This is one such rare book focusing on arts, which promotes new insights in early childhood.

Art has always been in the background when it comes to preschool education. Many think there is nothing to *plan* or teach when it comes to art. After all, what is there to educate children about having fun with colors? So where is the need to plan an art class? Such is the perception. Teachers shun art because they lack the imagination to bring life to art and art to life. There is another appalling belief that Masters' works should be tackled when one *matures*. How does one mature? A child, irrespective of age, grows depending on the exposure to genuine works — be it language, literature or arts.

Artists who are a mystery to a majority of the common man are tough subjects to introduce to preschool children. But Jayanti believes that it is imperative — the arduous task should be done. Her book reveals how it should be done. When children are exposed to artworks of Masters, they see the beauty and interpret it to the next level of creation. And that is what Jayanti has done — exposing children to Master Art and firing their imagination.

A mentor who 'delivers' is the one who has the will, develops the skill and builds his/her expertise based on experiences. Ordinary mentors are likely to feel intimidated due to lack of knowledge and ideas to create these kinds of artistic encounters. However, Jayanti has a striking plan to

introduce some of the most challenging Masters of art to children. Mentors need to follow Jayanti's strategy. Maybe each one can have their own "artistic modification" (Joe Renzulli) based on one's context. Jayanti's book could be a great tool in everyone's hand irrespective of the age group of children they deal with. This book is also an excellent resource for parents for organizing art experiences for children at home.

The world will be different for children when they, a genius in the making, interpret the Masters, in his/her way. Jayanti lets us know that 'messy' art is process-based art, and it is original imagination in action. Her advice to allow children to experience artistic explorations without interference has depth and relevance regarding brain development too. Art will satisfy children's innate need to express when they want and how they want. With the advocacy of this book, the readymade solution of cutting the arts budget to "save" money may also change as parents come to realize the importance of art in the development of their kids.

There is no dearth of the mundane and irrelevant material on the subject of teaching art — in particular for teachers. However, there is a vacuum when it comes to guiding educators, parents, and children with structured activities. *The Art of Math and Science* fills that void by providing advanced material for the teachers and exciting experiential opportunities for children. It advocates freedom of choice — an essential element of 'creation.' This book should be made mandatory in all training programs in the realm of early childhood.

Dr. M Srinivasan
Founder and Chairman
GEAR Innovative Intl. School

# ACKNOWLEDGMENTS

**66** *Others have seen what is and asked why.*
*I have seen what could be and*
*asked why not.* **99**

PABLO PICASSO

**Thank you to all my co-conspirators and supporters who have always encouraged me to ask, "Why not?"**

Thank you, Amma, and my siblings, JP, Anant, Jayapriya, and Sreepriya, for always believing in me.

Thank you Akshay for teaching me the importance of "why not?" You have shown me the wonder of the "why not" in my life, and I am still learning. I am so grateful to have you as a son.

Thank you, Somesh for always encouraging me in my crazy pursuit of "why ever not!

Thank you, Srini, Savi, Sunny, Madhu and Savera, for whom the obvious answer is: "Jayanti?! ...why not?"

Thank you, **Ritesh,** for saying,
"Another book, why not?"

Thank you, **Frona and Ted** for providing me with a dozen
reasons for why I should be writing this book.

Thank you, **Shelley and Natalie,** for saying,
"You're insane...but why not?"

Thank you to my **partners-in-crime at UCLA** for helping
me stay sane: You are all amazing, and I know I could not
have done this without your continuous support

Thank you, **Susan,** for validating my passions. "A book on
the art and science of math? Yes, why ever not! "

Thank you, **Sudha,** for telling me how much you enjoyed
reading the book, again validating my "why not?"

And thank you, **Ula, Maximilian and Stella** for making my
"why not" a reality.

THANK YOU.

# REFERENCES

**INTRODUCTION**

1. Jackson-Hayes, L. (n.d.). "We don't need more STEM majors. We need more STEM majors with liberal arts training." The Washington Post. www.washingtonpost.com/posteverything/wp/2015/02/18/we-dont-need-more-stem-majors-weneed-more-stem-majors-with-liberal-arts-training

2. Preschool Learning Foundations for the State of California. www.cde.ca.gov/sp/cd/re/psfoundationsvol1intro.asp

3. The NCERT. www.i-add.net/pdfdownloads/DPSE%20Curriculum.pdf

**WASSILY KANDINSKY**

4. https://commons.wikimedia.org/wiki/File:Vassily_Kandinsky,_1913_-_Color_Study,_Squares_with_Concentric_Circles.jpg

5. www.wassily-kandinsky.org

6. www.naeyc.org/tyc/article preschoolers-as-abstract-artists

7. Bergland, C. (2013, Nov 15). "Hand-Eye Coordination Improves Cognitive and Social Skills." Psychology Today. www.psychologytoday.com/blog/the-athletes-way/201311/hand-eye-coordinationimproves-cognitive-and-social-skills

**VINCENT VAN GOGH**

8. www.vangoghmuseum.nl/en/vincents-life-and-work

9. www.vangoghgallery.com/misc/biography.html

10. Gopnik, A. (2010, Jul). "How Babies Think." Alison Gopnik. www.alisongopnik.com/papers_alison/sciam-gopnik.pdf

11. www.d.umn.edu/~jbrutger/Lowenf.html

**MICHELANGELO**

12. www.italianrenaissance.org/a-closer-look-michelangelos-painting-of-the-sistine-chapel-ceiling

13. www.michelangelo.org

14. Rice, M. M. (2014, Feb 18). "What is the teacher's role in supporting play in early childhood classrooms?" VCU. www.ttacnews.vcu.edu/2014/02/what-is-the-teachers-role-in-supportingplay-in-early-childhood-classrooms

15. www.education.com/reference/article/egocentrism

**GEORGIA O'KEEFFE**

16. https://prints.okeeffemuseum.org/detail/460763/okeeffe-sunflower-new-mexico-1-1935
17. www.metmuseum.org/toah/hd/geok/hd_geok.htm
18. Encourage Learning. (n.d.). Smithsonian Education. www.smithsonianeducation.org/ families/time_together/encourage_learning.html
19. https://edsource.org/2015/art-appreciation-helps-young-children-learn-to-think-and-express-ideas/77734

**INDUS VALLEY CIVILIZATION**

20. http://archaeologyonline.net/artifacts/indus-sculpture
21. http://tinkerlab.com/five-easy-steps-for-talking-with-children-about-art
22. www.si.edu/content/seec/docs/article-artwithtoddlers.pdf
23. https://edsource.org/2015/art-appreciation-helps-young-children-learn-to-think-and-express-ideas/77734
24. www.arts.gov/art-works/2014/importance-taking-children-museums

**JACKSON POLLOCK**

25. www.jackson-pollock.org
26. www.jackson-pollock.org/#prettyPhoto
27. Edwards, M. (2011, Apr 11). "Help your child develop the 'crossing the midline' skill." North Shore Pediatric Therapy. http://nspt4kids.com/ parenting/help-your-child-develop-the-crossing-themidline-skill
28. "Encounters." (2010/11). Reggio Emilia. www.reggioemilia.org.nz/pdf/Encounters%20summer%20 2010_11.pdf
29. Bongiorno, L. (n.d.). "How Process Art Experiences Support Preschoolers." NAEYC. www.naeyc.org/tyc/article/process-art-experiences

**PABLO PICASSO**

30. www.pablopicasso.org
31. http://abcschoolart.blogspot.com/2014/12/two-faced-portraits-5th-grade.html
32. http://theconversation.com/three-questions-not-to-ask-about-art-and-four-to-ask-instead-29830
33. www.earlychildhoodaustralia.org.au/nqsplp/wp-content/uploads/2012/05/EYLFPLP_E-Newsletter_No26.pdf
34. Kochhar-Bryant. (2010). "What does it mean to educate the whole child?" SAGE www. sagepub.com/sites/default/files/upm-binaries/34869_ Kochhar_Bryant__Effective_Collaboration_for_ Educating_the_Whole_Child_Ch1.pdf

**MAX ERNST**

35. https://pavlopoulos.wordpress.com/2010/12/27/the-mathematics-of-max-ernst/

36. http://plumedeplombe.blogspot.com/2012/04/max-ernst-levity-and-gravity-in-his.html

37. https://pavlopoulos.wordpress.com/2010/12/27/the-mathematics-of-max-ernst

38. "Be Reggio Inspired: Learning Experiences." (2013 Mar 20). Let the Children Play. www.letthechildrenplay.net/2013/03/be-reggio-inspiredlearning-experiences.html

**WARLI PAINTING**

39. www.warli.in

40. www.naeyc.org/tyc/article/shapes_space

41. www.bostonchildrensmuseum.org/sites/default/files/pdfs/rttt/stem/english/STEM_Guide_English.pdf

**HENRI MATISSE**

42. www.wikiart.org/en/henri-matisse/icarus-1944

43. www.henri-matisse.net/cut_outs.html

44. "Fine Motor Development." (n.d.). School Sparks. www.schoolsparks.com/early-childhood-development/fine-motor

**DON GUYOT**

45. www.designsponge.com/2013/02/past-present-marbled-paper-round-up.html

46. Kohn, A. (2001, Sept). "Five Reasons to Stop Saying 'Good Job!'." Alfie Kohn. www.alfiekohn.org/article/five-reasons-stop-saying-good-job

**KILIM WEAVING**

47. https://en.wikipedia.org/wiki/Kilim

48. Friedrich Froebel. (n.d.). Friedrich Froebel www.friedrichfroebel.com

49. Maria Montessori (1870 - 1953). (n.d.). Women's Intellectual Contributions to the Study of Mind and Society http://faculty.webster.edu/woolflm/montessori.html

50. www.psychologytoday.com/blog/the-athletes-way/201311/hand-eye-coordination-improves-cognitive-and-social-skills

**PIET MONDRIAN**

51/52. Anderson, C. (2010, Mar). "Blocks: A Versatile Learning Tool for Yesterday, Today and Tomorrow." NAEYC. www.naeyc.org/files/yc/file/201003/ HeritageWeb0310.pdf

**BYZANTINE EMPIRE MOSAIC**

53. www.nga.gov/content/ngaweb/features/byzantine/mosaic.html

54. https://nrich.maths.org/2487

## BANDHANI

55. https://en.wikipedia.org/wiki/Bandhani
56. www.earlychildhoodnews.com/earlychildhood/article_view. aspx?ArticleID=607

## BATIK

57. https://en.wikipedia.org/wiki/Batik
58. http://auntannieschildcare.blogspot.com/2013/07/real-tools-for-kids-dangerous-or.html

## M.C. ESCHER

59. www.mcescher.com/gallery/recognition-success/no-105-pegasus/
60. www.tessellations.org/tess-escher1.shtml
61. www.getreadytoread.org/early-learning-childhood-basics/early-math/early-math-matters-preparing-preschoolers-to-succeed

## ABORIGINAL DOT ART

62. www.katsushikahokusai.org/the-complete-works.html
63. www.nma.gov.au/collections/highlights/papunya-collection
64. https://eclkc.ohs.acf.hhs.gov/hslc/tta-system/teaching/eecd/domains%20of%20child%20development/mathematics/pp41_65.pdf

## KATSUSHIKA HOKUSAI

64. www.katsushikahokusai.org/the-complete-works.html
45. www.massaudubon.org/contentdownload/13467/209564/file/PreKTeachingUnits-TREES.pdf
66. Pica, R. (n.d.). "Take it outside!" Early Childhood NEWS. www.earlychildhoodnews. com/earlychildhood/article_view. aspx?ArticleID=275

## CONCLUSION

67. www.exploratorium.edu/education/ifi/constructivist-learning
68. https://kindergartenfuninroom101.wordpress.com/reggio-emilia

# ART BOOKS TO READ TO CHILDREN

1. The Noisy Paint Box:
   The Colors and Sounds of Kandinsky's Abstract Art
   *– Barb Rosenstock*

2. Henri's Scissors
   *– Jeanette Winter*

3. Action Jackson
   *– Jan Greenberg*

4. My Name Is Georgia
   *– Jeanette Winter*

5. Van Gogh and the Sunflowers
   *– Laurence Anholt*

6. Picasso and the Girl with a Ponytail
   *– Laurence Anholt*

7. The Warli Tribe: The First Agricultural Society (India)
   Economy and Culture Storybooks
   *– Hye-Eun Shin*

8. Ready to Dream
   *– Donna Jo Napoli*

9. Exploring Landscape Art with Children
   *– Gladys S. Blizzard*

10. The Pop-Up Book of M.C. Escher
    *– M. C. Escher*

11. The Graphic Work of M C Escher
    *– M.C. Escher*

12. Coppernickel Goes Mondrian
    *– Wouter van Reek*

13. Michelangelo's World
    *– Piero Ventur*